WEAVING
in the PERUVIAN
HIGHLANDS
DREAMING PATTERNS, WEAVING MEMORIES

WEAVING
in the PERUVIAN
HIGHLANDS
DREAMING PATTERNS, WEAVING MEMORIES

Nilda Callañaupa Alvarez

Preface by Wade Davis

Editor: Linda Ligon
Translator: David Burrous
Copy editor: Veronica Patterson
Illustrations: Ann Sabin Swanson
Cover design: Susan Wasinger
Interior design: Elizabeth R. Mrofka
Production: Trish Faubion, Nancy Arndt

Cover images: Three generations of weavers from Accha Alta, and belt loom weaving from Chinchero.

 Center de Textiles Traditionales del Cusco
603 Avenida del Sol
Cusco, Peru

Printed in China by Asia Pacific

Library of Congress Cataloging-in-Publication Data

Alvarez, Nilda Callañaupa.
 Weaving in the Peruvian highlands : dreaming patterns, weaving
memories / Nilda Callañaupa Alvarez.
 p. cm.
Includes bibliographical references and index.
Summary: Handwoven fabrics comprise the living history and culture of the Peruvian highlands from Cusco to Machu Picchu and beyond. Fabric patterns with evocative names reflect the landscape and events in vivid color, evolving over time. The weavers who create these fabrics in the time-honored way are keepers of the culture and sustainers of a noble but difficult lifestyle in tune with the earth. They raise llamas and alpacas for fiber, collect plants for natural dyes, spin yarn on primitive spindles, and weave acres of cloth on simple backstrap looms just as their forebears have done for thousands of years. They weave clothing, rugs, bedcovers, potato sacks, hunting slings, and sacrificial fabrics for themselves and their villages, and for sale to supplement their meager incomes. Travellers visiting the area (hundreds of thousands a year from North America alone) are drawn to this authentic, well-crafted work and given the opportunity to collect it at every street corner and rail stop. Weaving in the Peruvian Andes is their guide to quality, understanding, and appreciation. They will learn how pattern names such as meandering river or lake with flowers relate to the geography and history, and how the traditional natural materials and colors enhance the value of the work.
 ISBN-13: 978-1-59668-055-5
 1. Hand weaving—Peru. 2. Indian textile fabrics—Peru. I. Title.
TT848.A7155 2007
746.1'40985--dc22
 2007028581

Dedication

To my family: my husband and my two sons, from whom I took time to do my research.
To my parents, especially my mother, who was an important part of my weaving life.
And to all my extended family.

To my foreign friends who shared their cultural and textile experience and appreciation.

To the weavers in all the communities, especially the elders.

This book is also dedicated to the memory of Edward Franquemont, weaver, scholar, friend.

Department of Cusco

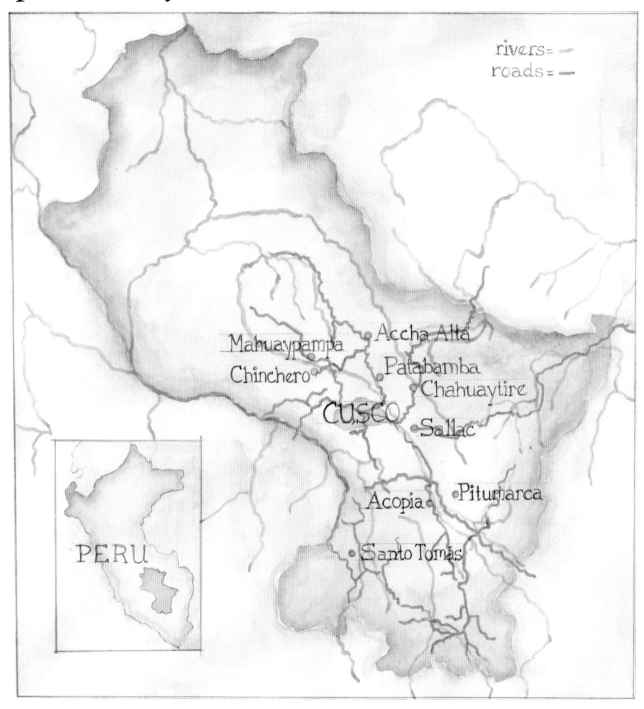

rivers =

roads =

Mahuaypampa

Chinchero

Accha Alta

Patabamba

Chahuaytire

CUSCO

Sallac

Acopia

Pitumarca

Santo Tomás

PERU

An Affirmation of Continuity

In the winter of 1982, while engaged in ethnobotanical research with a team of anthropologists and botanists, I was fortunate to live among the people of Chinchero, a traditional Andean community located some twenty miles by road from the ancient Peruvian city of Cusco. When I first met Nilda Callañaupa Alvarez and her wonderful family, she was twenty-two but seemed wise beyond her years. I wasn't the only person to sense in her a young woman marked by destiny. She taught all of us many things that first season and has continued for more than twenty-five years to be my friend and guide to the extraordinary Andean world, with its fusion of past and present. In that world, pre-Columbian ideas and themes have been forged into a new amalgam inspired by both the winds of modernity and the pious cloak of Catholicism that has enveloped the mountains for more than 500 years.

Simply put, Nilda is one of the most remarkable individuals I have known. She is a woman who transcends culture, who exists out of time and space, an artist and scholar of immense vision and achievement. But what makes her truly great is her integrity, the fact that despite any number of alluring temptations she has remained utterly grounded in a spirit of place, loyal to community and landscape. More than any other, this trait links her to the distant past—to the archaic memory and currents of ritual that have fundamentally informed her life.

I recall vividly those first weeks in Chinchero. We were there at the invitation of Chris and Ed Franquemont, anthropologists and weavers who had lived in the community for several years and raised their children there. Chris, in particular, had a fascination with plants and would go on to become an authority in Andean ethnobotany. Our immediate task under her leadership was to complete a thorough survey of the useful plants of the Chinchero region, whose small hamlets are spread over some 135 square kilometers at elevations ranging from 3,000 to 5,000 meters.

By day we worked furiously, collecting medicinal herbs on the flanks of the sacred mountain Antakillqa, edible algae from the pools and ponds scattered upon the rich plains and verdant fields of Yanacona and Ayllupungo, exotic ornamentals among the gorges of Yanacona, where wild things thrived and rushing streams carried the rains to the Urubamba, the holy river of the Inca. By night we mostly had fun, drinking and dancing, exchanging *kintus* of coca leaves and blowing the essence to the wind. Nilda's mother, Doña Guadelupe Alvarez, famously asked whether any of us had been born of mothers. She was perhaps reassured about us on the day when we stood side by side beneath the vault of the church, in a space illuminated by candles and the light of pale Andean skies, with newborn children in our arms. We held boys and girls swaddled in white linen as an itinerant priest dripped holy water onto their foreheads and spoke words of blessing that brought the infants into the realm of the saved. That afternoon three of us became godfathers, assuming ties of expectation and reciprocal obligations that would forever link us to the community. From me, my compadres hoped for support for my

godchild's education, perhaps the odd gift, a cow for the family, a measure of security in an uncertain nation. From them, I wanted the chance to know their world, an asset far more valuable that anything I could offer. It is a relationship that I have always cherished.

Though the highland flora was spectacular and the agricultural skills of these descendants of the Inca nothing short of genius, what impressed me most about Chinchero was the daily round, the accumulation of gestures that together spoke of an intimate and profound reverence for the very soil upon which the village lay. The village, of course, was not merely the adobe and thatch houses clustered around the small church. It was the totality of the people's existence—the ancient ruins that ran away from the village and hung like memories at the edge of cliffs overlooking the river, the fields cut into the precipitous slopes of Antakillqa, the lakes on the *pampa* (plain) where sedges grow, and the waterfall where no one went for fear of meeting Sirena, the malevolent spirit of the forest.

For the people of the village, every activity was an affirmation of continuity. At dawn, the first member of the family to go outside formally greeted the sun. At night, when a father stepped back across the threshold into the darkness of his small hut, he invariably removed his hat, whispered a prayer of thanksgiving, and lit a candle before greeting his family. Before the morning labor in the fields began, there were always prayers and offerings of coca leaves for Pacha Mama (Mother Earth). The men worked together in teams forged not only by blood but by reciprocal bonds of obligation and loyalty, social and ritual debts accumulated over lifetimes and generations, never spoken about and never forgotten. Sometime around midday, the women and children would arrive with steaming cauldrons of soup, baskets of potatoes, and flasks of *chicha* (corn liquor). The families feasted together every day, and in the wake of the meal, work became play, the boys and girls taking their place beside their fathers—planting, hoeing, weeding, harvesting. At the end of day, the women scattered blossoms on the field, and the oldest man led the group in prayer, blessing the tools, the seed, the earth, and the children. This spirit of place, this sense of life as community, manifests itself in ways that are both exquisite and profound.

It was within the comfort and constraints of Chinchero that Nilda came of age. As a child she accompanied her mother to the market in the plaza from which the Inca terraces fall away to an emerald plain, the floor of an ancient seabed. Beyond the plain rise the ridges of the distant Vilcabamba, the last redoubt of the Inca, a landscape of holy shrines and lost dreams, where Tupac Amaru waged war and the spirit of the Sun still ruled for fifty years after the Conquest. With her friends and sisters, she played on the village green, a plaza where Topa Inca Yupanqui, second of the great Inca rulers, reviewed his troops. On Sundays and Holy Day, she attended Mass with her family in the old Colonial church that the Spaniards built at the height of the ruins, thus affirming in the eyes of the people the inherent sacredness of the place. By the age of six, she was in charge of flocks of sheep, which she led up the slopes of Antakillqa, where she met the grandmothers who taught her to spin and to weave. At the age of eight, she first attended school, where she soon rose to the top of her class in virtually every subject.

Through the early years of Nilda's life, Chinchero was by no means isolated from the social, political, and economic forces that swept through the nation. The strength of the traditional *ayullus* (local self-governing organizations) and the fact that major haciendas had never been imposed upon the valley insulated Chinchero to some extent from the impact of

the Agrarian Reform under Velasco that convulsed the country for a decade beginning in 1965. Nevertheless, the pressures of modernity came to bear. To survive, farm families invariably sought a link to the cash economy of urban centers, and in time virtually every Chinchero household had at least one child living in Cusco or Lima. Tourism was a constant presence, with hundreds of foreigners descending on the town during the Sunday market.

In a bizarre incident in the early 1970s, the American film director Dennis Hopper, flush with cash after the success of Easy Rider, brought a Hollywood film set to the village, transforming the center of town into a western stage for the making of The Last Movie, a feature film that would never be released. On a more positive note, sympathetic travelers and anthropologists, including the Franquemonts, came to live in the community and by their presence and through their interests helped validate in the eyes of the people the importance and value of tradition, even as they personified the dazzling possibilities of travel and education.

Nilda absorbed all of these influences. Encouraged in particular by her close friendship with Ed and Chris Franquemont, she began to look beyond Chinchero toward a greater world. Against considerable odds, she became the first woman and indeed the first person from her community to attend university, where she studied history, anthropology, commerce, and foreign languages, graduating from the Universidad de San Antonio Abad del Cusco in 1986. A sojourn at Berkeley allowed her to perfect her English. Her talent as a weaver brought invitations to travel and teach throughout North America and Europe. Within a few years of being a solitary shepherd girl on the flanks of Antakillqa, she was attending international conferences and leading weaving demonstra-

tions and workshops at major institutions such as the Smithsonian, the American Museum of Natural History, and the Textile Museum in Washington, DC.

For many young people in rural communities, education becomes a one-way ticket out, a means of severing contact and obligations and moving ahead into a new life. To her credit, Nilda viewed education as an obligation to return. In 1996, the establishment of the Center for Traditional Textiles of Cusco realized her dream of creating an educational organization for the study and celebration of the weaving traditions of the southern Andes. It is an extraordinary institution. At the Center, men and women gather to share knowledge and techniques, young boys and girls come of age, and weavers from rural communities stay and sell their products directly to the consumers at prices that do justice to the quality and inherent value of the cloth.

Situated at the heart of Cusco, in the shadow of the Coricancha, the Temple of the Sun, the Center is much more than a museum and research center. It is a symbol of pride and cultural survival, a hive of activity in which ancient techniques of weaving, spinning, and natural dyeing come together to create inspiring textiles of a quality that hasn't been seen in the Andes for many generations. These textiles are sacred cloth, woven from the threads of memory by Andean hands that are at last firmly in control of their destiny. Each tells a story, and each story is a prayer for the well being of the people, the land, and the community.

—*Wade Davis*
2007

Acknowledgments

This project represents several years of effort, and since no book is an individual effort, I would like to express my deepest thanks to all those who have guided me, shared time, given information, and helped in my research efforts of the last decades.

I owe first thanks to all the weavers, especially the elders, of Chinchero, Pitumarca, Accha Alta, Chahuaytire, Patabamba, Sallac, Chumbivilcas, Acopia, Ccachin, Region de Ocongate, and Lares. To Chris Franquemont, for encouraging me to write this book alone and for serving as my guide. To Paula Trevisan, who worked very closely with me; to Linda Ligon, who put in great time and effort; and to Mary Frame who provided valuable feedback and suggestions. To the photographers whose work has helped elucidate and enrich the meaning of the text. To my family: my husband and children, who understand and help me in my work. I owe them for the time I missed being with them in this very important part of their lives. To the board members of the Center for Traditional Textiles of Cusco, who encouraged me to undertake this project and who shared their experiences along the way. To Interweave Press for committing to distribute the book in North America, and to Linda Ligon, the Delta Foundation, and Thrums LLC for funding the printing of the book. And to the CTTC staff, who gave extra time in so many ways.

It is impossible to list all the people who played an important role in this project, so finally I would like to thank all the weavers who are continuing to keep our textile traditions alive. And to the many people who encouraged and helped me in the challenge of writing about Quechua weaving in another language.

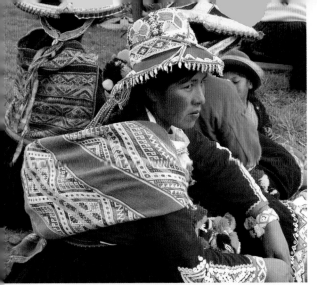

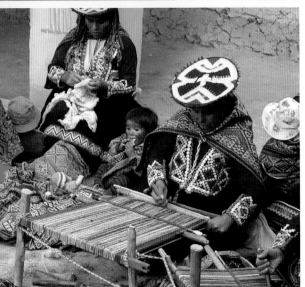

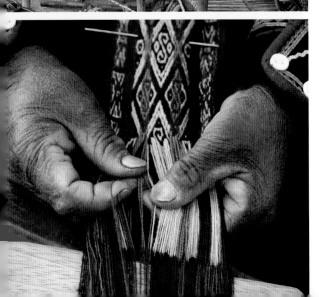

Contents

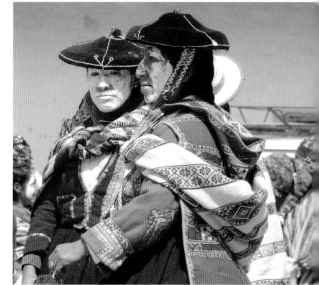

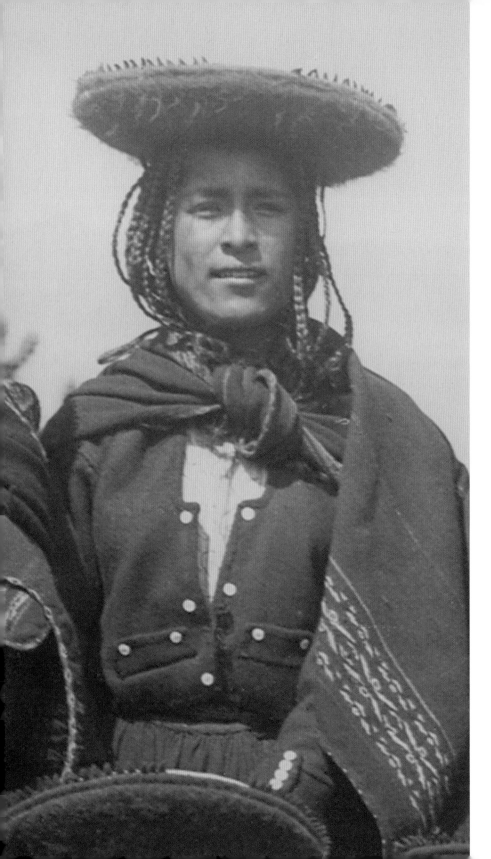

An Endless Thread

In today's world, we take cloth for granted. We are surrounded by it, from the time we get up and put on our clothes in the morning, until we go to bed under our blankets at night. It comes from machines, it costs little, we throw it away without a second thought when it's worn out. This is how it is in the world of modern industry and ever-changing fashion.

But there is another kind of cloth, and that is the kind of cloth you will learn about in this book. It is cloth made thread by thread, by the hands of the people. Each piece has its own life, a reflection of the spirit, skill, and personal history of its maker.

When I was growing up in Chinchero in the 1960s, traditional cloth had little value to the people in my village. The country folk still spun and wove, and the older and more traditional women of Chinchero as well. But in families with Spanish heritage, the men put on modern trousers to go to their jobs, and all the children wore modern clothes to school. To do otherwise would be looked down upon.

The author's mother, a weaver in Chinchero, circa 1945.

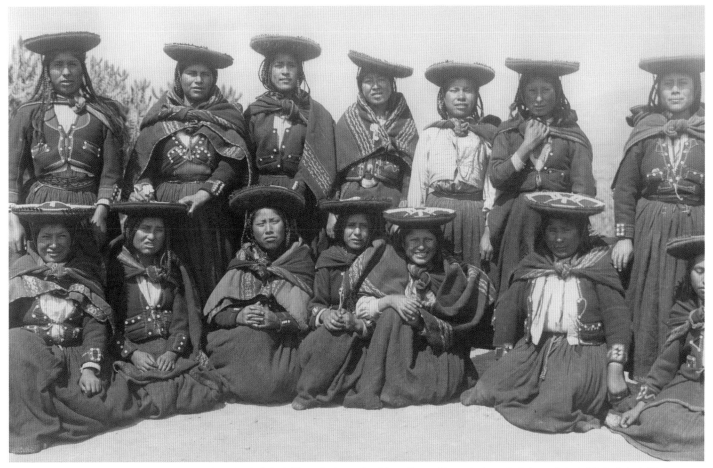

Weavers of Chinchero, circa 1945. Back row, from left: *Lucia Quispé, *Elena Cusicuna, Guadalupe Alvarez (the author's mother), Juana Quispé, *Maria Quispé, *Centaco Cjuiro, Aleja Callañaupa. Front row: *Sabina Choque, *Rita Huaman, *Gregoria Callañaupa, Maria Cardinas, *Gabina Callañaupa, Alejandrina Cusihuaman, *Isabel Choqueconza. Those with asterisks are deceased. Photo by noted Peruvian photographer Martin Chambi, 1891-1973. Published with permission of his estate.

On my mother's side of my family, my grandfather was Spanish, and my grandmother was Quechua. My grandfather died early, and my grandmother then supported her family with weaving. She taught my mother to weave as well, but only simple patterns that would not identify her as Chinchero. Weaving was a trade, not a cultural expression.

My parents earned their livelihood raising animals: cows, bulls, sheep, and so forth, and from agriculture mainly. I began going into the fields with my mother when I was only four years old, and by the time I was six, I was trusted to watch a flock of sheep by myself. My father didn't believe children should start going to school too young, so I didn't start until I was eight. So I had several years of time in the fields with our sheep. During these years, I made a wonderful friend, an elderly woman, Doña Sebastiana, a shepherd who was a highly skilled spinner. We became very close. Her spinning was so fine, and she spun so quickly, that I dreamed at night of spinning. This is where my

love of handmade cloth began, and my desire to learn from my elders.

I started school, and quickly became a good scholar. My father was insistent that I study hard and spend time on my homework. I enjoyed learning in school, but at the same time, I was developing my interest in the traditional weaving. My father would come back from trips bringing cloth from distant villages, and each piece was unique. "How was that made?" I would ask myself. I experimented, trying techniques I had seen older women doing. I did this late at night in my room, when my father thought I was studying. My mother knew what I was doing, and did not discourage me. My father would say, "Weaving will never make you prosperous."

I started my first weavings and designs with the help of my mother, but then as I began to teach myself more patterns, I began to see the logic of it, and to feel the excitement of accomplishment and creativity. I would take my work out to offer it for sale to the tourists. I remember so well selling my first pieces, *jakimas*, or narrow belts. A group of travelers were attracted to them, but I had only three. So we cut them into parts with a stone so each person could have a portion. Another time, I was weaving a horse pattern in a technique called pebble weave. I learned it by analyzing a piece from one of the distant regions. I had woven only a little bit, and a tourist bought it, loom and all. I could see that there was value in creating the more intricate, traditional styles rather than the usual simple pieces made of bright synthetic yarn that most people were weaving for the tourist trade. My family had begun to have financial difficulties, and I was proud to be able to contribute some income.

By the time I finished secondary school, I was the only girl remaining in a class with more than thirty boys. My grades were very good;

I have learned that each piece of cloth embodies the spirit, skill, and life experience of an individual weaver.

I was in the one of the first places in my class, which should have meant a full scholarship to the university in Cusco. But the scholarship was given to a boy. This confirmed my resolve to go to university. My father encouraged me in my further studies as well. So I left my familiar community and went to the city, where I supported myself mainly with my weaving while attending school and studying a tourism program which combined languages, history, archaeology, cultural anthropology, and business.

Living in the city was such a change. Time and time again I faced discrimination of one sort or another. Meanwhile my weaving skills were growing, and I was noticing that good traditional weaving was being highly valued by collectors. Families were selling off their old pieces for good prices. My own work, higher in quality and intricacy than typical tourist goods, was claiming better prices as well. Yet everyone was saying that traditional weaving was not a valued activity! "What is wrong with us – are we stupid?" I would ask myself.

During my university studies, I had an opportunity to get a grant to travel to California to study the textile history of different parts of world and experiment with different looms and clothing styles. I lived in Berkeley for six months, and when I came back home I was torn, not just between the worlds of Chinchero and Cusco, but now the world of North America as well. They were all so different, and they all made some claim on me. I remember sitting in my family's courtyard in Chinchero and feeling very confused. How could I be all these different people? What path should I choose?

In the end, it was weaving that held my life together. I realized that I could be who I was: a weaver. I could live in Cusco, dress in a modern way, sell my weaving in the galleries

and markets. I could travel to North America to teach the traditional skills of my people. I could be with my family in Chinchero, and encourage others there and in other communities to recapture the excellence of traditional weaving.

The ensuing years have been full and rewarding as I have worked, with the help of others, to develop the Center for Traditional Textiles of Cusco. Weavers have come from all over the region to show and sell their work there, to learn from each other, and to feel a sense of pride in who they are and what they do.

I have learned that each and every piece of cloth embodies the spirit, skill, and personal history of an individual weaver. Weaving is a living art, an expression of culture, geography, and history. It ties together with an endless thread the emotional life of my people. I hope this book will help you enter that world. I hope that as you see the continuity of history as reflected in our clothing, the profound skills that go into the creation of the cloth, and the deep cultural meanings of the patterns as they are passed down and evolve over time, that you will feel in some way a part of a shared human experience.

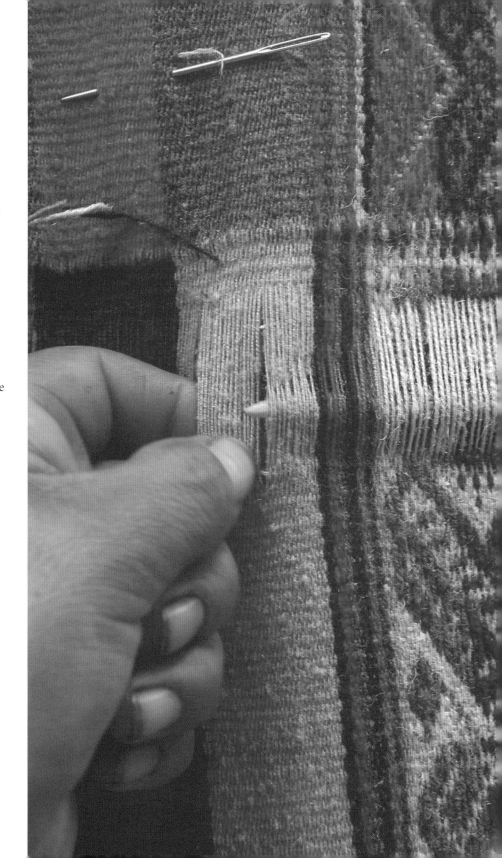

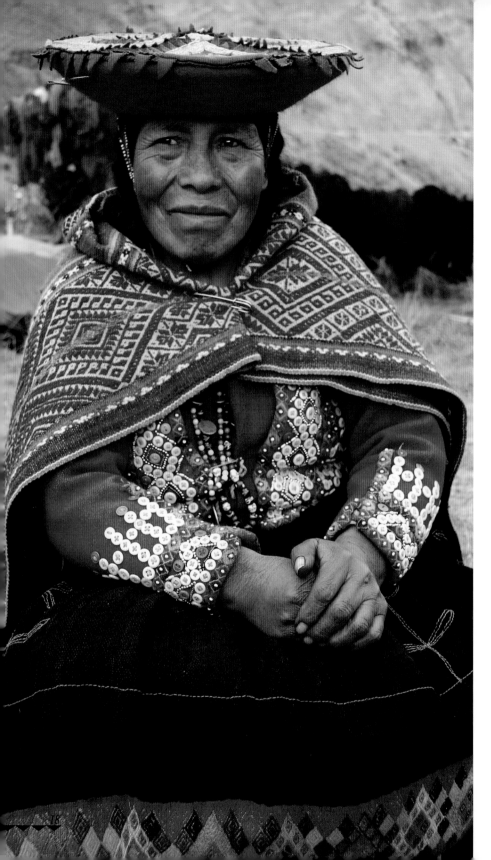

Traditional Clothing of the Cusco Region

In the sixteenth century, the Spanish arrived in the Cusco region, the capital of the Incan empire. The Spanish culture profoundly changed the lives of the native people. Among the more visible changes were those in clothing, as the native population began adopting elements of style from the Spanish settlers. In many places the regional dress was replaced almost completely by new garments, except that they were made of native fabrics and materials. Some clothing articles of the Incan period have persisted, such as *llicllas* (women's mantas or shawls), *unkus* (long shirts), and *ojotas* (sandals).

Today's traditional clothing is actually the result of continual change, especially in its colors and decorative elements. The evolution occurred as regional markets made different types of cloth and decorations, such as buttons, braids, and sequins available.

In recent decades, traditional clothing has been rejected little by little, especially by the young

Cipriana Mamani Ccorcca of Accha Alta, wearing traditional dress. The orange reds in her manta are typical of the weaving of Accha Alta.

people in the cities and more urban regions of the district. Many have come to prefer the readily available factory-made clothes (commonly called mestizo's clothes). Even in communities out in the Andean countryside, children wear uniforms and contemporary clothes to school. They wear their traditional clothing only on special occasions.

▲▲▲

The majority of people in the Andean highlands are country people who wear their oldest and simplest clothes for their daily activities. Their clothes for festivals, weddings, and dances, on the other hand, are made with great care and are prepared with much anticipation, sometimes years before an event.

Traditional clothing has always differentiated people by region, district, and community. Even villages that are geographically very close, perhaps divided by no more than a river, a mountain, or a road, may have distinct clothing styles. Clothing can also indicate a person's marital status, occupation, artistic skills, and economic status, serving as a sort of introduction between strangers.

Traditional dress is also an indication of the wearer's inner state: It can signal sadness (the loss of family or home), including the sorrow of severe poverty. In many cases, if people have problems, such as with their health, they sell their weavings for the money they need to help with their difficulties.

Clothing can indicate the principal economic activity of a region because a style of dress becomes associated with the kinds of products the wearers bring to market. For example, people from the valleys bring produce such as vegetables, corn, and fruit; those from the highlands bring potatoes, meat, and fiber. And clothing may be made for or associated with a particular festival.

▼▼▼

And how do the people feel today about weaving their traditional clothing? In the recent

For my grandparents, the whole matter of clothing was much simpler. They themselves say that most of the women still like their traditional skirts and jackets, and the men, their shirts. . . . but our clothing has changed since synthetic yarn appeared with many brilliant colors and we began to weave and adorn with [them].

Aquilina Castro (Pitumarca)

Because we have suffered so many indignities on the part of the authorities and the mistis (Spanish or white people) for wearing traditional clothing, we no longer want our children to wear traditional clothing. . . .

Marcelina Callañaupa (Chinchero)

We no longer feel we have to accept these insults. If we hear some bad comment about us, we immediately tell the speakers that we are people equal to them and that there is no difference between us. . . . We can say that because of us, there are enough tourists in Cusco.

Twelve to fifteen years ago, when we began to work with the Center to restore our traditional clothing and agreed to wear it on our trips to the city, people looked at us as if we were foreigners. On the buses, people were put off by our skirts and tried to push us aside. But now, little by little, we are being accepted. We like our clothing and put it on with pride. It is something personal that we made ourselves. If we hear negative comments, we defend ourselves. In the past, our parents did not protest and did not demand respect. Now things are changing, although slowly. Now, sometimes people in the government and educators ask us to go to meetings with our traditional clothing and we feel very proud. Few still feel ashamed

Benita Ccana and Aquilina Castro (Pitumarca)

If we put on the clothes of the mestizo, almost no one can identify our origin. It is almost like we lose our identity. When we go to the big cities, this is what happens. But when we return, we wear our special clothing to incorporate ourselves back into the life of our community.

Carmina Ylla (Chahuaytire)

past, they often felt shame because they were shunned or ridiculed in the cities. But now, little by little, they and their clothes are being accepted and even taken for granted. Weavers from different communities who work with the Center are trying to revive the use of traditional dress and bring it to the same level of excellence and acceptance as their other weaving. Only in communities far from the urban center are the traditional garments still made: skirts, mantas, shirts, jackets, ponchos,

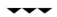

In order for young boys to be strong, they must be wrapped or fastened with a very taut belt. Now, it isn't done like it was in my time. Then, the baby could rest well whether it was on your back or in a bed

Pilar Ojeda (Patabamba)

We wove wide, thick belts for the men so that they could carry heavy loads from the harvest and their backs would be supported.

Rosa Quispe (Chinchero)

carrying bags, caps, and vests. But even in the highest and most remote communities, merchants sell mantas machine woven of cheap synthetic yarns that have a short "life" compared to the clothes.

Although the women of Chahuaytire wear *monteras* (traditional hats), the hats are made in the area of Ccatca. They're brought in for sale because the local people don't know how to make them any more. Today, certain regions, such as Ccatca and Chinchero, have come to specialize in fabricating the monteras.

According to the women of Chahuaytire, the clothing of the best quality—made with delicacy and abundant with decoration—is that of the unmarried

young women. Their garments have the most complex woven patterns, the finest yarns, the most vivid colors, and the most elaborate embellishments. These special clothes demonstrate highly personal creative expression and pride.

The weavers of Chahuaytire now wear their traditional garments with pride. They report that people in the cities sometimes come up to them and greet them with, "Brother, how good that you are wearing our traditional clothing and keeping it alive." Sometimes, people recognize them from their clothing and ask, "How are things in Chahuaytire?" or they ask about a particular person in the community. If people in the cities still try to discriminate against them, they resist.

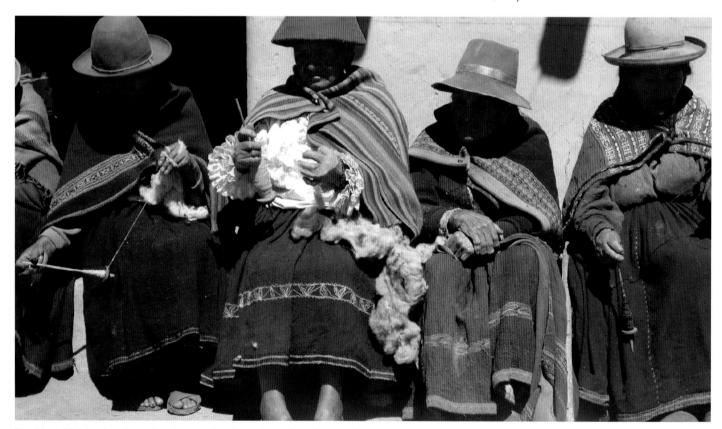

The elders of Patabamba spin continually, even when they no longer have the strength to weave.

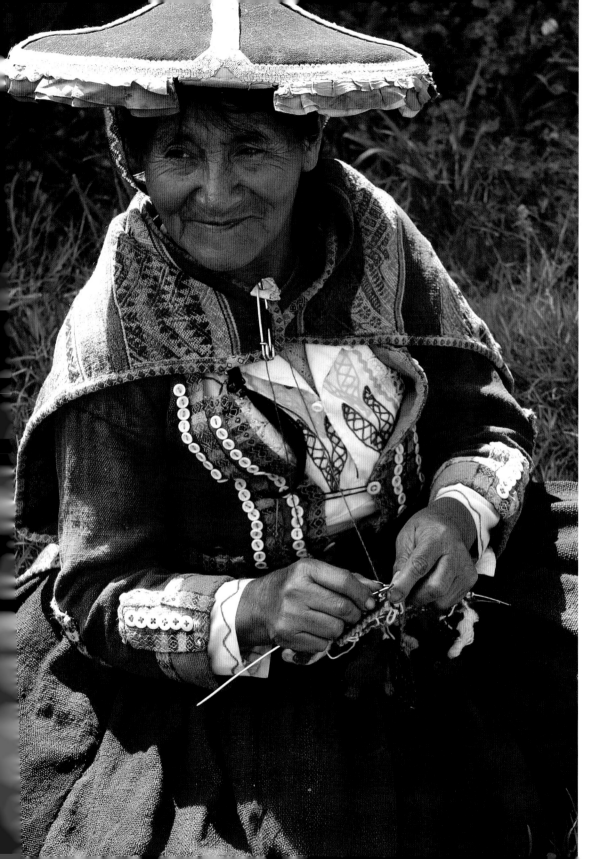

Natividad Huanca of Pitumarca, wearing dress typical of her community. Note her embroidered *aymilla*, or blouse. She is knitting a *chullo* of fine yarn.

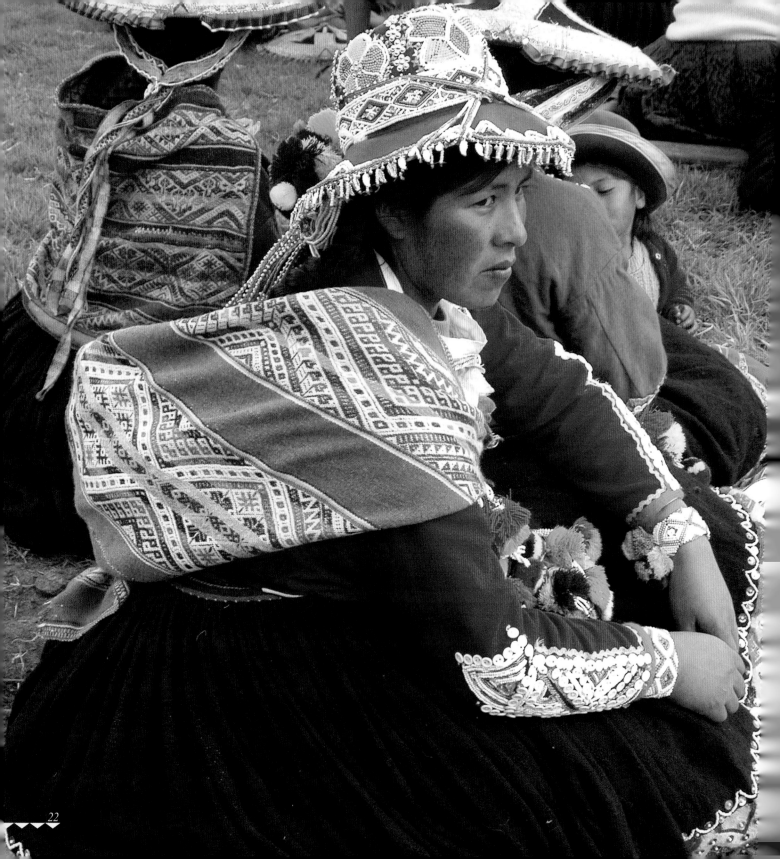

Common Items of Traditional Clothing

Because of the great variety of traditional clothing in the different regions, such as the highlands and valleys, I'll give only general descriptions of a few typical articles of clothing. Even within a region, similar garments can vary greatly in name, detail, and personal significance.

Women's Clothing

Aymilla: A type of shirt made of plain-weave woolen fabric, worn by both men and women. The shirts vary by community in color and ornamentation. In recent years, for women, the aymilla has been almost completely replaced by the modern *camisa de la mujeres* (woman's blouse), usually made of white commercial

Our clothes reflect our family's wealth and our success, and they also show our skill in making them . . . By weaving [our clothes], we give ourselves a personal seal.

Benita Ccana (Pitumarca)

The clothes that I make now that I am married and have children aren't equal in any way to the clothes I made when I was single. I don't think that I could equal them now

Genoveva Choque (Pitumarca)

During our courting period, the young men try to collect wachalas *(finely woven small textiles) from the young girls they admire or simply because they will be proud to have them from different girls, although now this custom is changing*

Nazario Turpo (Ocongate)

fabric and decorated on the front and sleeves with colored embroidery. Usually a *kurpino* (vest or waistcoat) made of the same cloth and with the same embroidery is worn over the blouse.

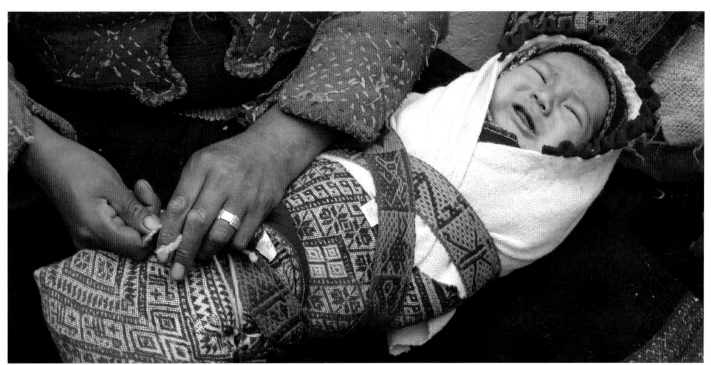

AT LEFT: Sonia Choque of Pitumarca. Her clothing shows the careful work and fine detail of many unmarried women. ABOVE: A baby in Accha Alta is firmly swaddled with a *chumpi.* This makes the baby easier to carry and stronger as he develops. Chumpis are also used to tie up pants and skirts.

Why do you look at me? Perhaps my clothing is not sufficient enough to indicate to you where I am from.

Gumercinda Huamán (Chahuaytire)

Through their clothes and weavings, we can tell where the people come from who travel to our community. We can identify them immediately, and many times we even know the purpose of their visit.

Lucio Ylla (Chahuaytire)

AT RIGHT: Dancers in Chahuaytire during the festival of *chiuchi llani*. Note the elaborate patterning on polleras and mantas.

AT FAR RIGHT: The hats of women in Accha Alta vary by generation. The young child and baby are wearing intricately knitted chullos with patterns of bobbles.

Chumpi: A woven belt or strap most often used by women, though men also use a chumpi to tie up their pants. Its use goes back to pre-Incan times. The chumpi is used to tie the waist of *polleras* (skirts) and to secure babies swaddled in a blanket carried on the back.

Juyuna or jobona: A type of women's jacket made of plain-weave wool fabric. The jacket is decorated with ribbons, buttons, beads, and embroidery. The colors as well as the forms of decoration vary by community. The women may make the jackets themselves, but in some communities there are people who specialize in making the jackets.

Lliclla, or *manta:* Lliclla is the Quechua word for manta. The lliclla is a square formed by two long strips sewn together. The width of the strips is determined by the use the manta will

be put to. The size of the lliclla varies from region to region and also depends on the lliclla's intended use. As an essential part of a traditional woman's costume, the lliclla is worn as a mantle that falls from the shoulders to the waist or even lower. It protects one's back from the cold and can be used to carry all manner of things, including babies. In some areas, such as Pitu-marca, it is used only for covering the back. Some llicllas are woven as simple, sturdy textiles for use in agriculture (where they're being replaced by burlap or plastic bags), but for festivals, weddings, and other special occasions they're woven of fine threads with complex designs and vivid colors.

Montera: A hat, adapted from the Spanish. Although women most often wear the mon-tera, in some communities, men who have been elected to official positions wear them for

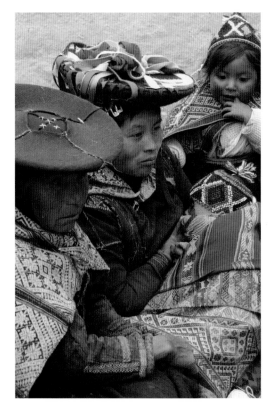

their terms of office. Some groups of dancers also wear them. The size, shape, and decorations of monteras vary from one place to another, but in general the hats have a straw brim with a decorated crown. Those worn for daily use are simple, while those saved for special occasions can be highly decorated. Monteras are held on with finely woven belts, bands, or ribbons that go by different names, depending on the region: They may be called *watanas, golones,* or *jakimas.* Some of the bands have elaborate patterns, and they may be edged with beads.

Pollera: A skirt is not only a basic article of clothing but a place where a woman can demonstrate her cleverness and skill. Polleras are usually made of handspun, plain-weave wool, although recently similar commercial fabrics have become common. Polleras are pleated and very full and are often worn one on top of another. They're embellished with woven multi-colored bands. When a pollera gets old, the bands are removed and applied to a new pollera. Creating a wardrobe of polleras takes many days, months, and even years of work. The lower bands on a skirt are usually *golones,* finely woven tapestry strips made on a narrow belt loom. Other decorative bands may be elaborately embroidered or appliquéd. Skirt lengths vary from short (knee-length) in some highland communities to long (almost covering the feet).

The women of Pitumarca point out that polleras are the most difficult clothing item to make because they require a lot of material as well as woven golones, *jileras* (belts for the waist), and *ollantinas* (woven bands of a single color).

AT LEFT: Two women of Santo Tomás, one weaving a belt. The women's clothing of this community is notable for its rich embroidered decorations and the wide appliqué borders on the skirts.

AT RIGHT: Andrea Gutierrez of Accha Alta spins while carrying her baby in her manta in the traditional way.

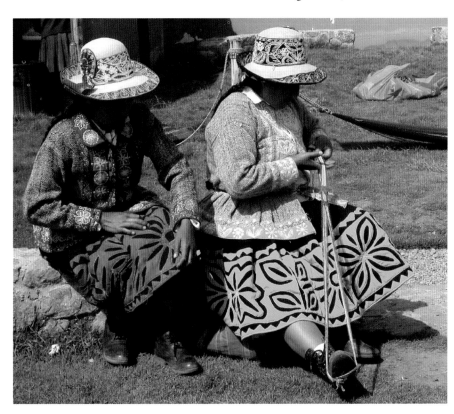

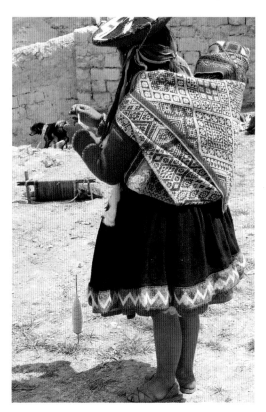

Women's Jobones and Camisas

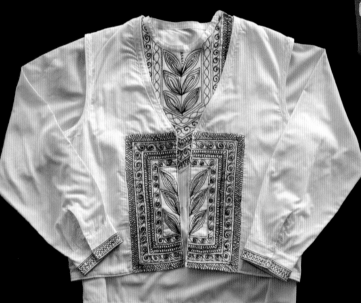

Pitumarca

Chinchero Camisa and Kurpino

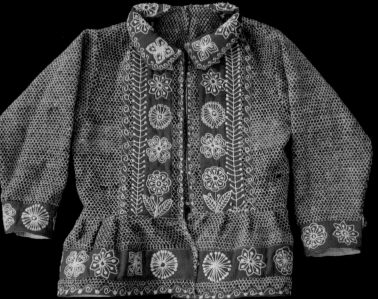

Santo Tomas Saco

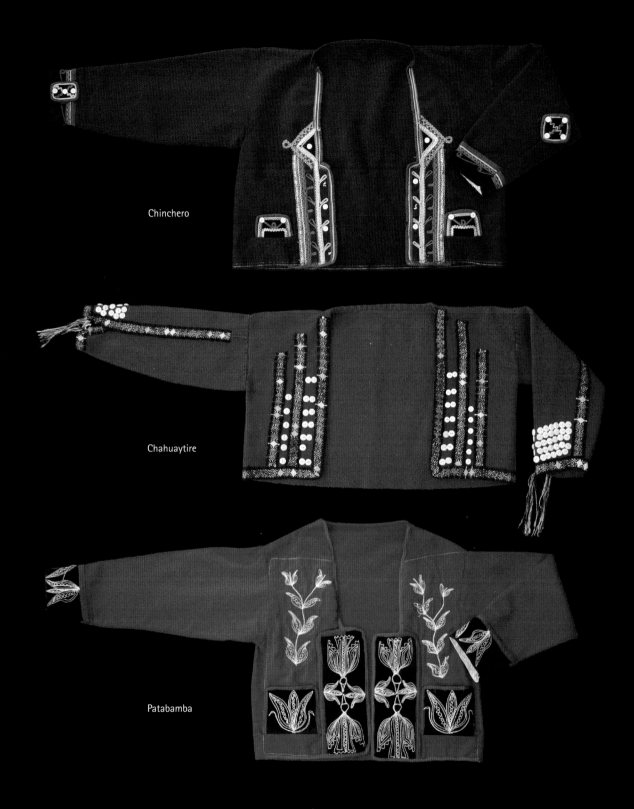

Chinchero

Chahuaytire

Patabamba

Monteras

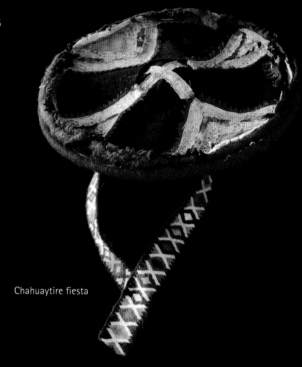

Accha Alta

Chahuaytire fiesta

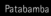
Patabamba

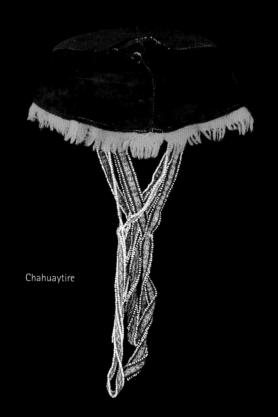
Chahuaytire

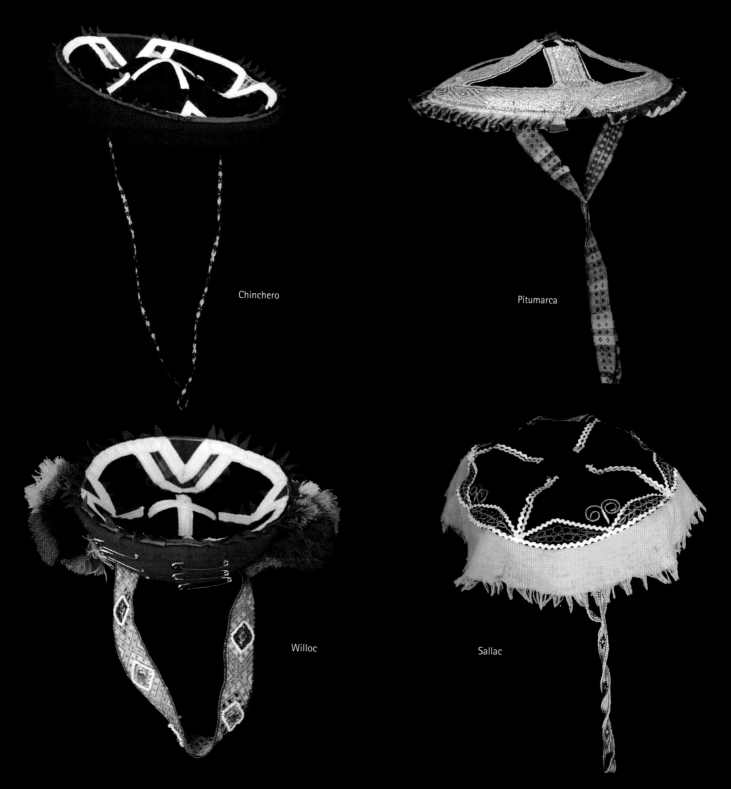

Chinchero

Pitumarca

Willoc

Sallac

Polleras

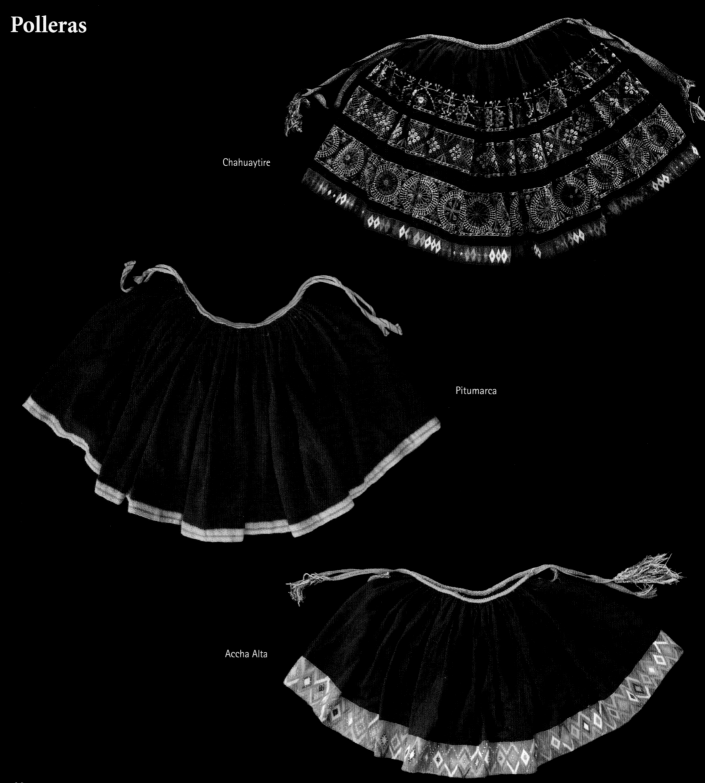

Chahuaytire

Pitumarca

Accha Alta

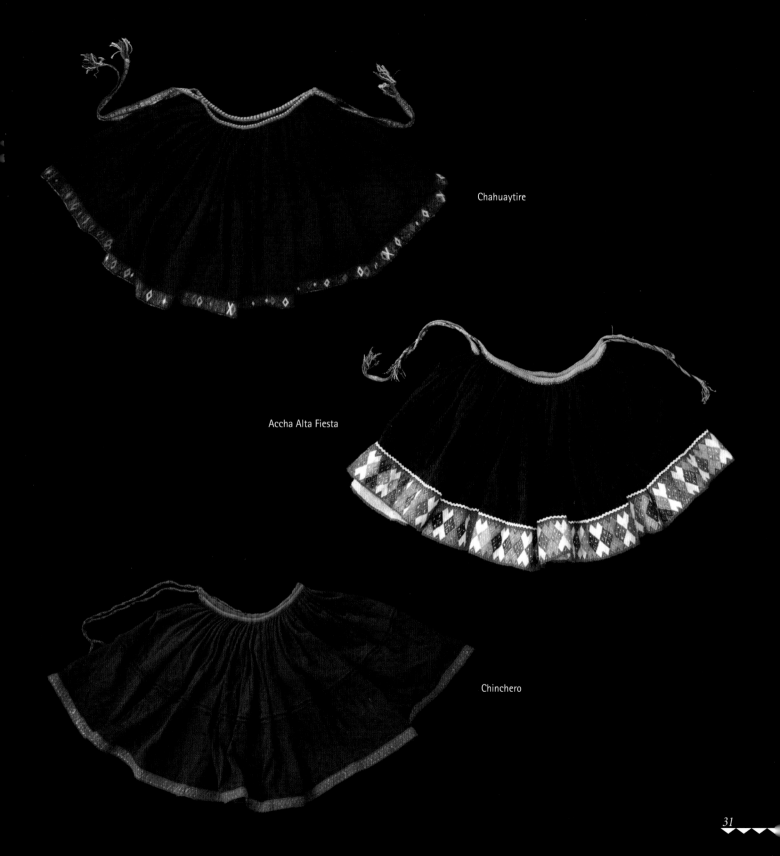

Chahuaytire

Accha Alta Fiesta

Chinchero

Llicllas, or Mantas

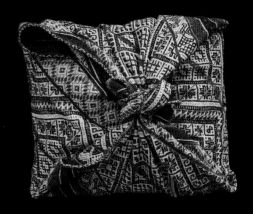

Accha Alta

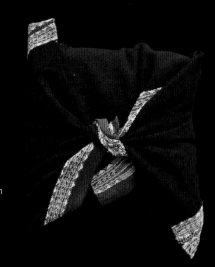

Antabamba Region

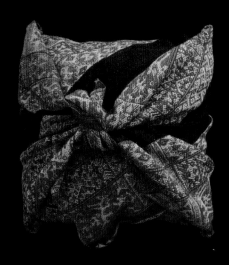

Cachin

Chahuaytire

Chinchero

Chinchero

Mahuaypampa

Pitumarca

Pitumarca

Sallac region

Santo Tomas

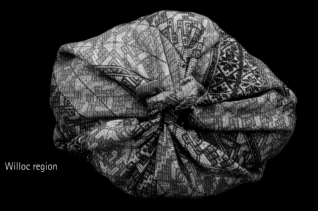

Willoc region

Unkuña: Small square textile used as a carrying cloth. The pieces vary in size and use from one region to another. Some are small, intricately patterned, and carried particularly by unmarried women for their personal use. Some women—for example, those from Ocongate and Ausangate—use unkuñas (sometimes called *wachalas*), to carry coca leaves and personal belongings for everyday use or during festivals. Unkuñas from Pitumarca are of especially fine quality. Some unkuñas, larger and more rustic in style, are used as lunch bags—for example, in Pisac and Willoc. Special unkuñas are also woven for ritual use; they may wrap coca leaves and sacred mythical objects to protect the home. The objects might include *enkayillus* (miniature animal sculptures).

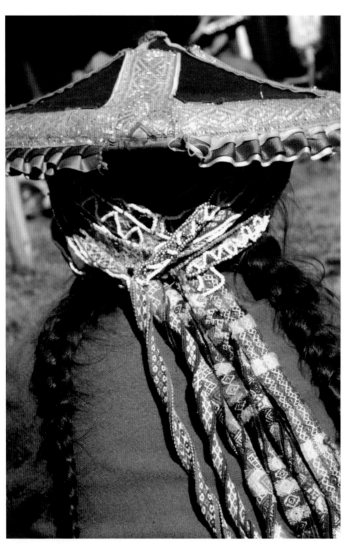

Hat bands – *jakimas* – from Pitumarca. The bands are highly decorative, with beaded edgings and a wealth of patterns and colors.

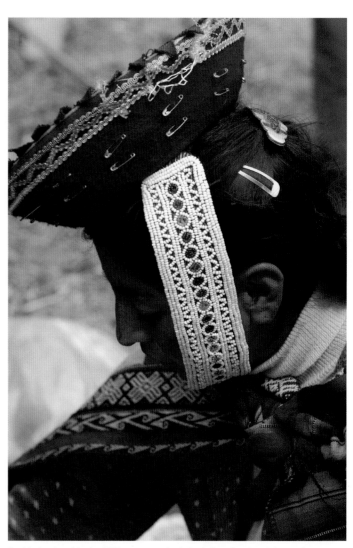

A wide hat band in the Willoc community is both functional and decorative.

Men's Clothing

Buchis: Short pants, adapted from the Spanish. Depending on the region, buchis might come to the knee or a little below the knee. They're worn only in certain communities, and usually just for special occasions. Most men today wear commercially made trousers.

Chilico: A vest or waistcoat made of woolen plain-weave cloth or other material adorned with buttons, embroidery, pins, and colorful fabric appliqué.

Chullo (also *verete* or *birrete*): A cap knitted of very fine yarn on five needles in many colors and patterns. In some areas, such as Chinchero, only women knit chullos; in others, such as

Men's ponchos in Accha Alta have similar patterning, but each is one of a kind.

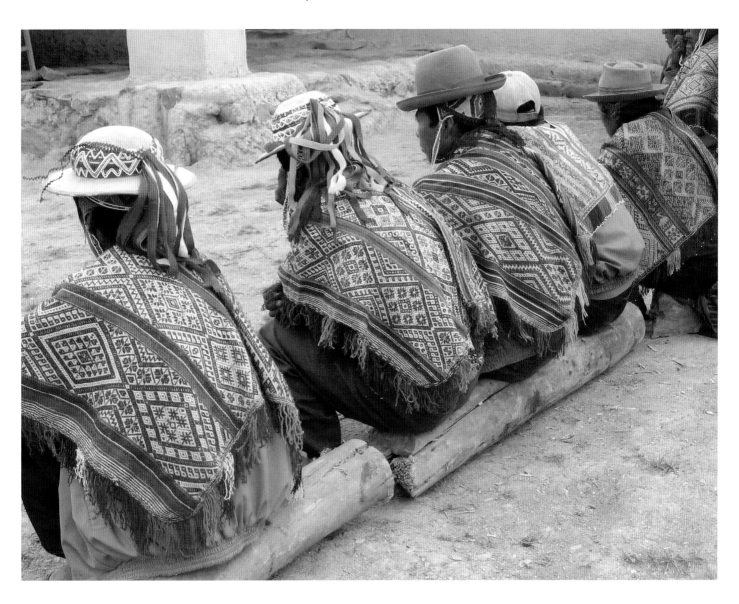

Chahuaytire, only men knit them. And in Accha Alta and other locations, both men and women knit the caps. The Spanish introduced knitting during Colonial times, and it has become a true art form in the Peruvian highlands. The cap shapes, colors, designs, quality, and ornamentation differ between regions. Chullos are usually made of sheeps' wool (though synthetics are used in some regions) and have simple to fancy decorations of buttons, beads, and ribbons. Often they're worn under other hats. In some regions, children also wear chullos.

Chuspa: A Quechua word meaning purse or bag. Men and women have used chuspas in their different forms for more than 2,000 years. Some highly decorated chuspas are used only for special occasions, as part of the dancers' costumes during festivals. Others are simpler in style and are used primarily by men to carry coca leaves. Both men and women use a smaller chuspa to carry money.

Poncho: Like the lliclla, the poncho is a rectangle formed of two long strips of fabric sewn together. For a poncho, though, an opening is left in the middle of the join for the head to pass through. The ample dimensions of the poncho let it fall in folds and cover most of the body. Although little is known about the origin of the poncho in the Andes, funerary bundles of the Paracas culture (600 BC to 200 AD) include garments of a similar shape. It isn't known, however, if they were worn in everyday life. Andean ponchos vary by region in size, color, design, and quality. There are small ponchos in such regions as Accha Alta, and Cancha Cancha, and much larger ones in regions such as Pitumarca. In urban areas, ponchos have been replaced by jackets.

Ojotas: Sandals of various styles, worn by both men and women, made of used tires and other kinds of rubber.

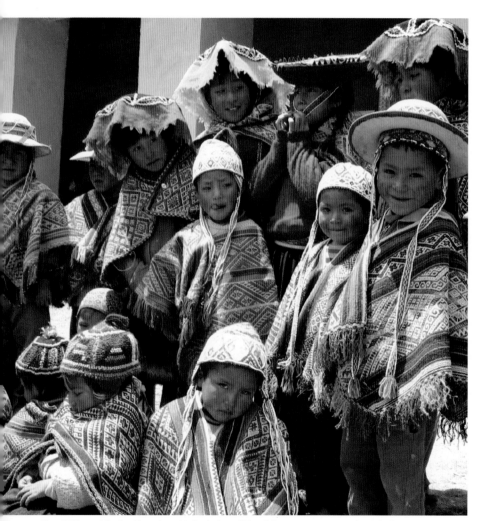
The children of Accha Alta take pride in their traditional finery – mantas, ponchos, chullos, monteras.

Pukuchu: A bag or purse made of leather from the skin or fur of baby alpacas or llamas. Often used to carry coca leaves.

Tablacasaca: A type of over-garment or tunic that almost completely disappeared. In some areas, community authorities once wore them. The men of Accha Alta have begun to make and use them as part of their revival of traditional clothing. Tablacasacas are made of black plain-weave wool fabric with many decorations such as embroidery, buttons, and pins.

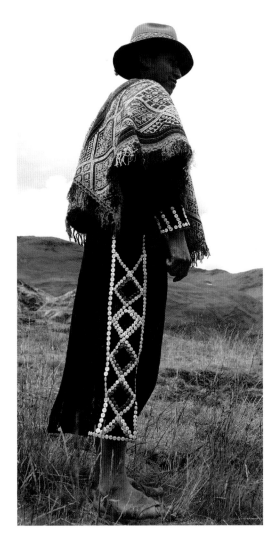

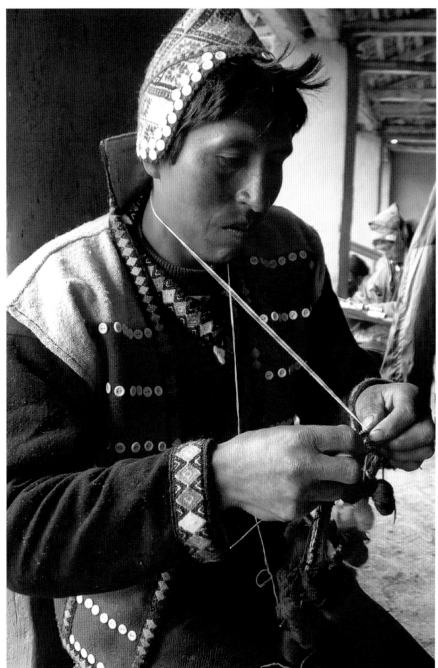

AT LEFT: Julian Huamán of Accha Alta wears a traditional tablacasaca — a long coat that has almost disappeared from use, but is being revived in his community. **ABOVE:** Tomás Sutta of Chahuaytire wears a traditional vest while knitting a chullo. Knitting is practiced by both men and women in some communities.

Chuspas

Accha Alta

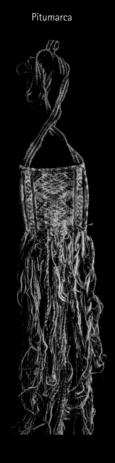

Pitumarca

Cachin

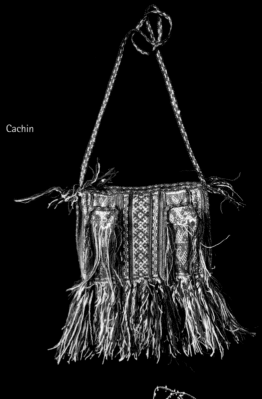

Ccatca

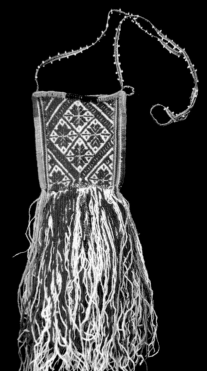

Ccatca

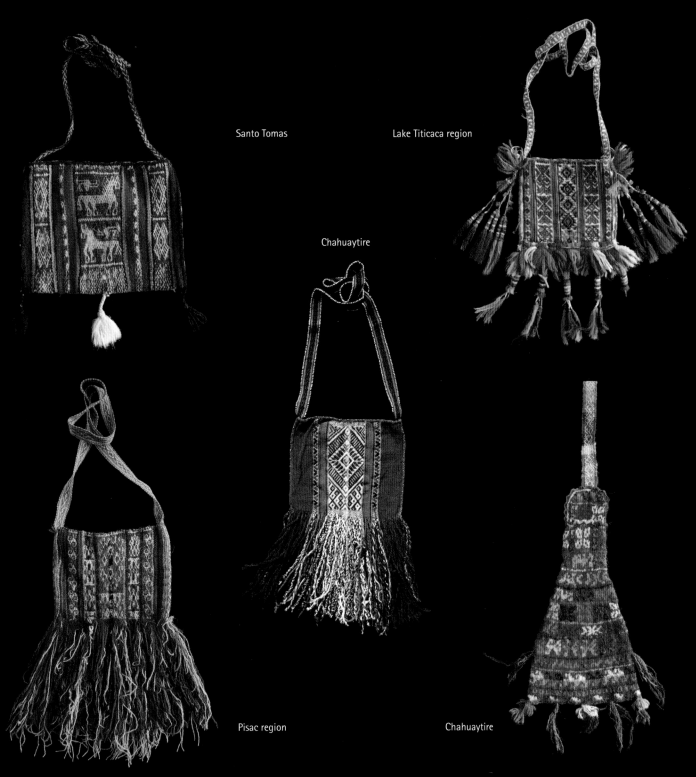

Santo Tomas

Lake Titicaca region

Chahuaytire

Pisac region

Chahuaytire

Chullos

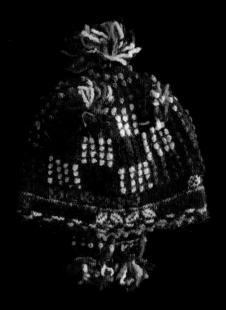

Pitumarca niño chullo

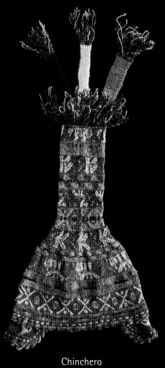

Cachin

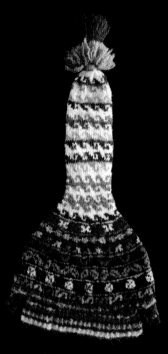

Pitumarca niño chullo

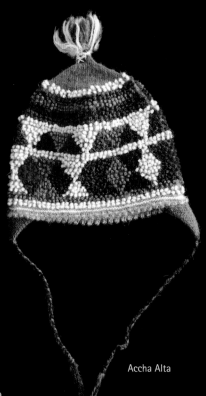

Accha Alta

Chinchero

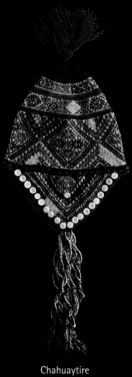

Chahuaytire

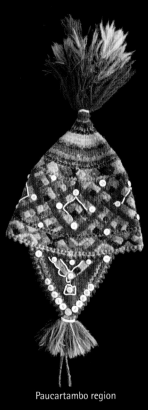

Paucartambo region

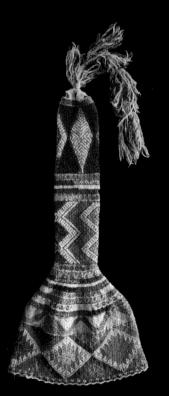

Pitumarca

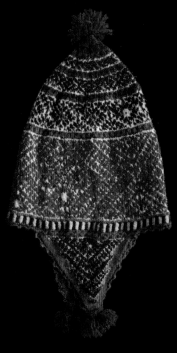

Sallac

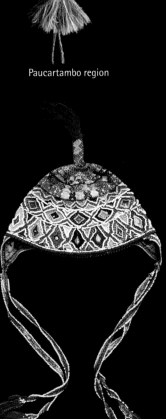

Accha Alta

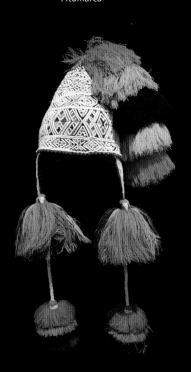

Ocongate region

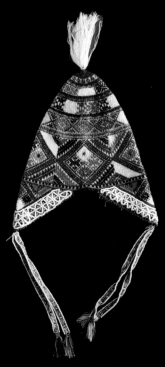

Chahuaytire fiesta chullo

Men's Jackets

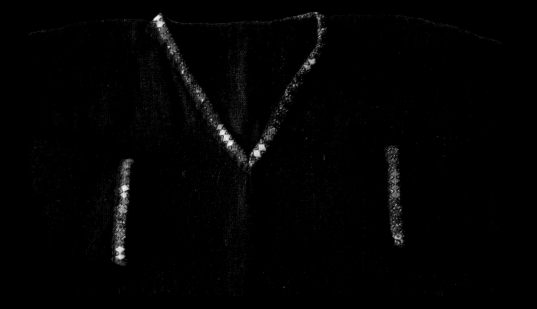

Chahuaytire

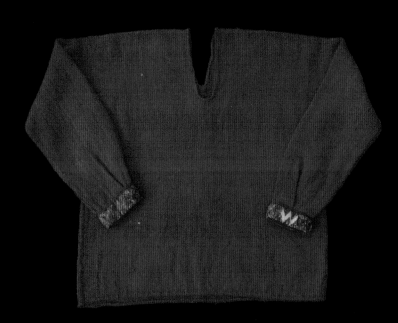

Accha Alta

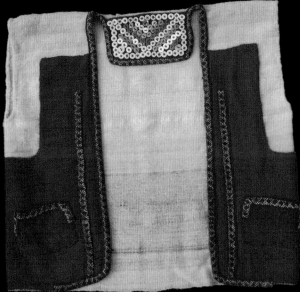

Accha Alta

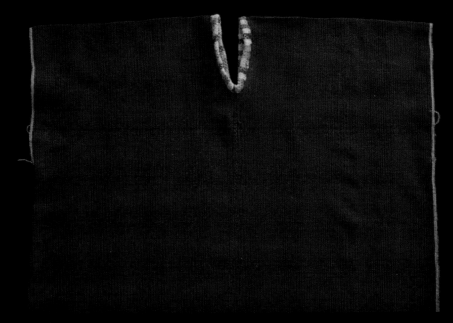

Q'eros

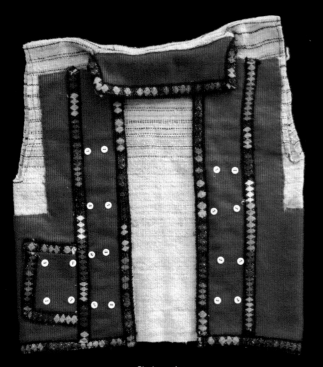

Chahuaytire

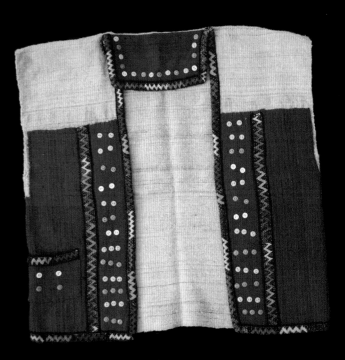

Chahuaytire

Ponchos

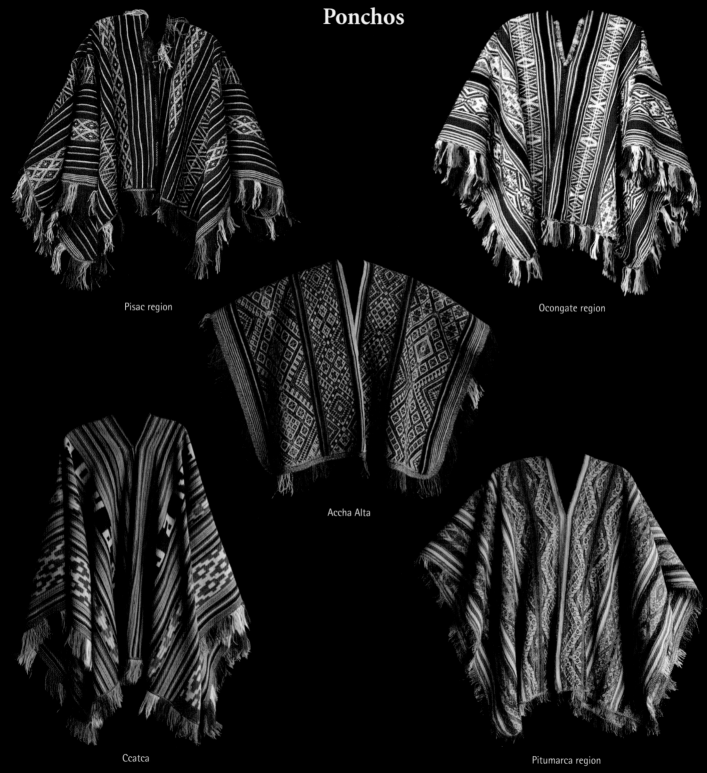

Pisac region

Ocongate region

Accha Alta

Ccatca

Pitumarca region

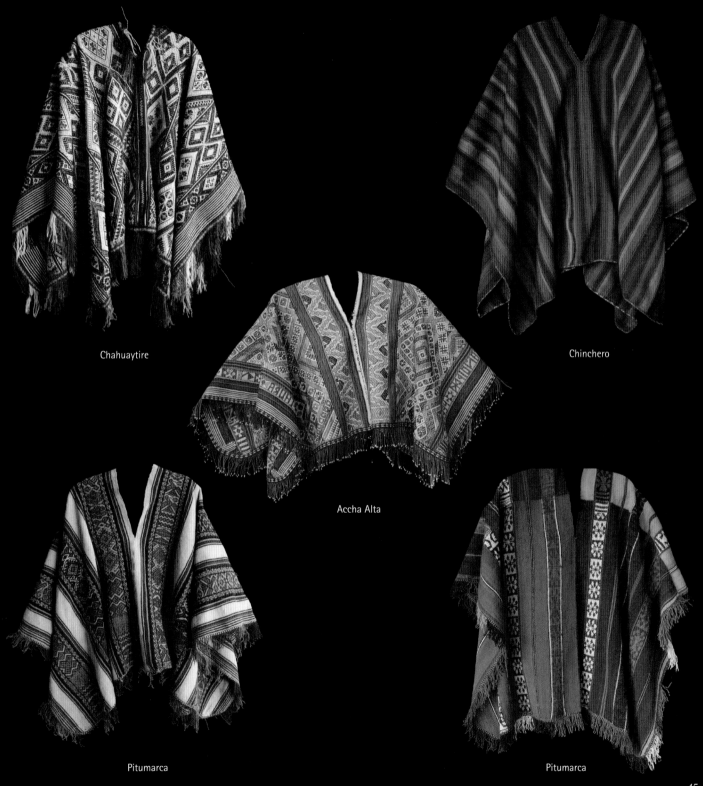

Chahuaytire

Chinchero

Accha Alta

Pitumarca

Pitumarca

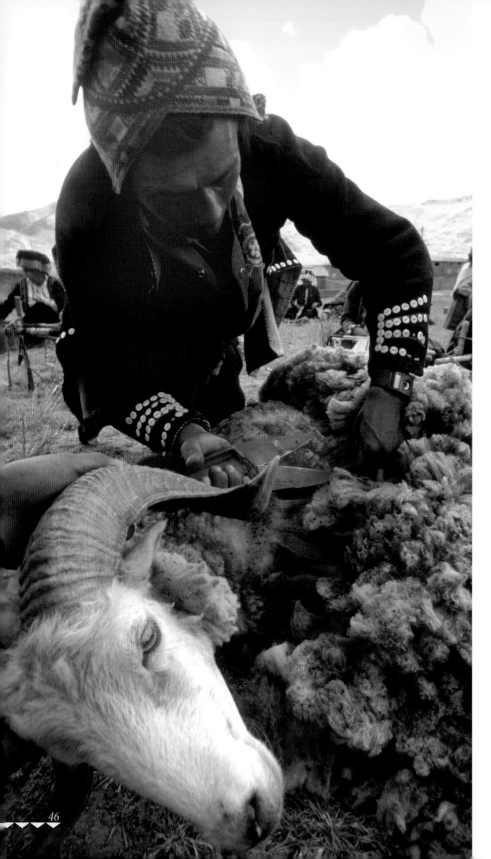

How Textiles Are Made

Materials

The Spanish introduced sheep to the New World in the sixteenth century. Since that time, sheeps' wool has been widely used for weaving clothing and other textiles. In some regions it has replaced native fibers such as the wool of alpacas and llamas, which have a tradition rooted in pre-Incan times. The use of other traditional fibers is limited as well. The guanaco, whose fleece resembles that of the llama, is in danger of extinction. The vicuña, which yields extremely fine wool, is scarce and difficult to domesticate. Its wool is used in few districts and only occasionally.

Natural fibers have a long and rich history in the high Andes, and though that history has evolved, they remain important for both economic and social reasons. Even though factory-made synthetic threads dyed in bright colors largely replaced natural fibers in the textiles in the Cusco region in recent decades, the value of those natural fibers endures. For many com-

José Yucra of Chahuaytire shearing a sheep. The animals are often allowed to grow two or three years' fleece before being sheared.

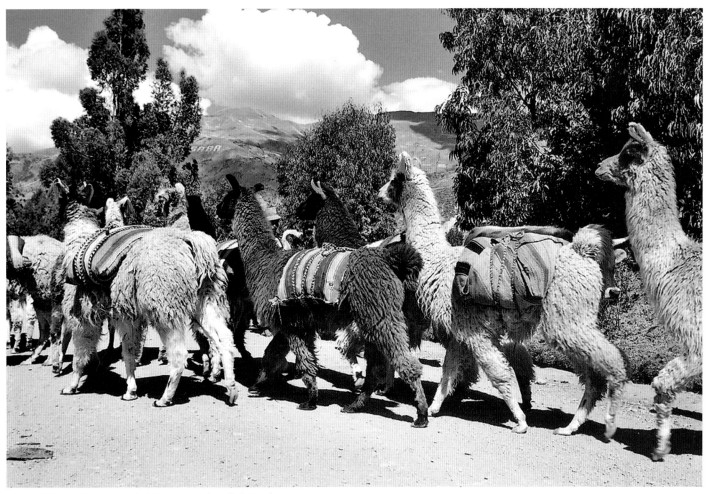
Llamas carry produce to market in handwoven sacks called *costales.*

I shear my alpacas every two years for my own spinning. If it is to sell, they are sheared each year because they will be processed in the factories [where the short fibers are easiest to process]. I shear my llamas every three years. . . . The best alpaca wool is from [those that were born at] the highest altitudes.

Hilaria Copara (Pitumarca)

The first shearing of an alpaca occurs the first year and we call it tuwe, *which means very soft. Later the quality of the wool begins to lessen. The wool from male alpacas changes more rapidly in thickness than that of the females. [Tuwe] costs a little more than normal*

Genoveva Choque
(Alturas de Pitumarca)

munities in the highlands, the principal activity continues to be tending alpacas, llamas, and sheep. Their wool may be sold for commercial use or bartered for synthetic yarn, clothing, and other products.

In those communities, survival depends on successfully raising animals and harvesting their wool. Even today, during certain times of the year, members of the highlands communities perform traditional rituals that include offerings to assure the fertility of their animals and a good fiber harvest.

In Anta Pitumarca, during a ceremony called *tupay*, for which people from different communities gather, groups of visiting dancers and musicians come to visit the villagers during the night with ceremonial wishes for the fertility of the alpacas and abundant wool harvests: "May your alpacas reproduce like the sand on the banks of the rivers," one wish begins. It continues, "May your wool inundate this place like the mist and be as abundant as the clouds."

Shearing

The animals are usually sheared during the mildest months, from December to April. The frequency of shearing varies from region to region—by the type of animal, the quality of forage available, and the altitude. Sheep are usually sheared every two or three years; alpacas are sheared annually if their wool is to be sold for commercial production, and every two years if it is to be spun by hand.

No wool is ever wasted. The best is spun and used for the finest weavings. The thicker and shorter fibers are spun and used for bulky weavings for daily use, such as blankets, and in some regions felted to make hats. The wool that has no other use is burned as fuel.

Alpacas are the most highly valued fleece animal in the Andes. Wool from their first shearing is extremely soft and fine and commands a high price.

Washing

Because sheeps' wool is greasy, it must be washed. The wool is washed after shearing—in warm water or on a sunny day. But weavers prefer wool that is washed while still on the skin of a slaughtered sheep, because there is less waste and the fibers stay aligned better, which makes them easier to spin. Because both are less dirty and greasy than sheeps' wool, alpaca wool and llama wool aren't washed before spinning. Instead, skeins of the spun yarn are washed before the yarn is used.

The women of Chinchero say that before commercial detergents appeared, they washed the wool using the roots of a plant called *Sacha paraqay* (family Nyctaginaceae) and the suds produced from washing the grain quinoa. They washed their fleece or yarn during the rainy season when there was enough water.

Spinning

Whether they're spinning the finest thread for delicate weavings or the coarsest thread for blankets, most spinners use a *phusca* (spindle), which consists of a circular weight on a stick. The size of the spindle varies according to the thickness of the thread being made: the smallest and lightest for making fine threads and the heaviest and largest for making thick threads. Weavers and their families produce their own thread; although women do the majority of the spinning, in certain places men also spin.

Children may begin to practice spinning when they're only six or seven years old. Sometimes spinning begins as a part of their games. Parents may make little spindles for their daughters, and the girls learn to spin by watching their mothers or other people around them. Young girls are often given inferior wool when they're learning to spin because their thread probably won't be fine or even enough to use

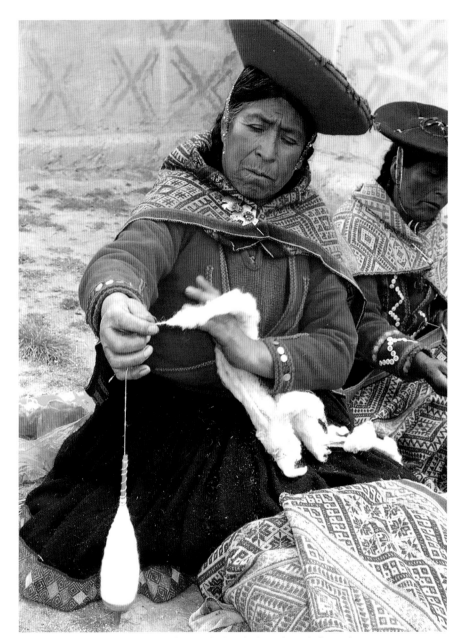

Nieves Cordóba of Accha Alta spins a fine, sturdy thread using a drop spindle, or *phusca*.

for weaving. By the time they are about ten years old, however, they're expected to produce usable yarn. Then spinning becomes a trusted

Still, though, I am able to spin, thanks to God. When I spin, I forget about my troubles and sorrows. Also, when I spin, I can sell [my yarn] and get what I need. There are times when I spin for other people and they pay me with their products such as potatoes, corn, and wheat, and they bring me coca leaves to chew as a gift. . . . Only when I die may I be done with spinning, although when we die we take our spindles. . . so perhaps we will continue to spin in the other world
 Emilia Yana (Pitumarca), age 80

At home I don't have time to spin, but when I go to herd my sheep or take trips to other communities, I frequently end up with a lot of yarn to weave.
 Aquilina Castro (Pitumarca)

I no longer have much strength, but I can still spin when I'm seated. Although the thread isn't as delicate (fine) as before because I have problems with my eyes and hands, I still keep busy.
 Marcelina Callañaupa
 (Chinchero), age 88

Now, some girls are waylacas *who don't know how to spin well and are already compromised, living with a man. Thanks to the fact that there is synthetic yarn to purchase, they can at least weave their manta to carry their baby. But in many cases their mothers have to give them yarn or the mother-in-laws makes them suffer.*
 Maria Huaman (Pitumarca)

assignment that mothers give their daughters. The girls most often spin when they're in the pastures watching the animals.

Because thread is of vital importance for producing textiles, making it is a lifelong activity. In old age, after women lose the physical strength to weave, many concentrate on spinning.

Women have the most time to spend on spinning when they're moving—walking around their small farms, herding their animals, and visiting other communities.

The quality of a weaving depends upon the quality of the yarn, and the yarn's quality is determined by the nature of the wool itself and by the skill of the spinner. Spinners value and find pleasure in weaving fine, smooth, strong yarn in order to have well-made weavings. For warp-faced weavings, one needs yarn that has been well twisted so that it won't break during the weaving process.

In some regions, where the people use ropes or slings of alpaca or llama fiber, men use a technique called *miskhuy* or *mismiy*, to make them. The process consists of twisting prepared fiber with a stout stick into strands of thick yarn. Depending on the end use, groups of two, three, or four strands are then gathered and twisted in the opposite direction, also using the stick. The result is a firm, tightly twisted, durable rope.

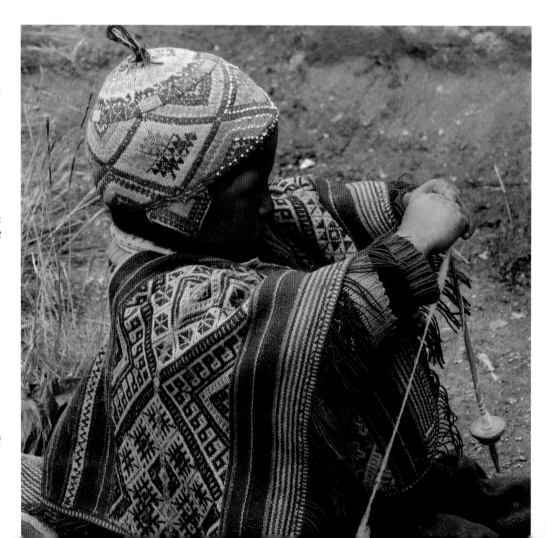

Winding, Skeining and Plying

Two single strands of yarn are rolled into balls, then skeined and washed. They can be plied (twisted together) in the opposite direction from which they were spun, or dyed before plying and kept in balls.

Dyeing

After commercial chemical dyes became available, dyeing handspun yarn with natural materials disappeared from the Cusco region for almost a hundred years. The synthetic colors were bright, and the dyes were easy and quick to use. In recent decades, though, the quality of chemically dyed synthetic yarns has declined, especially in colors such as blue, green, and brown.

Guadalupe Alvarez, a seventy-nine-year-old weaver from Chinchero, has never dyed with natural dyes, but her grandmother used natural dyes and her mother used to talk about the colors that came from different plants and minerals. She remembers her mother speaking of making yellow dye with *kiko* flowers, then adding a little aniline dye so the color would be more intense.

The weavers also used *anil* (indigo), a blue dye made from the indigo plant *Indigofera tinctoria*. Because the indigo wasn't available locally and took weeks to prepare, they would send their yarn to be dyed to other places where indigo was available and dyers were experienced in its use.

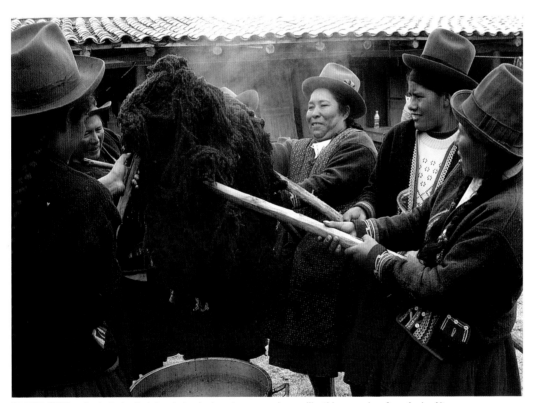

AT LEFT: Children begin to try their hand at spinning at a very early age, like this young boy from Accha Alta.
AT RIGHT: A group of women in Mahuaypampa dye yarn using cochineal, a traditional red dye derived from a beetle that lives on the *Opuntia* cactus (prickly pear). Cochineal yields shades of red ranging from deep red-purple to red-orange to pink.

I have heard people talk to my mother about natural dyes, but in reality, the powder dyes [aniline dyes] of those times were good and easy to use, so I wasn't interested in knowing about natural dyes. . . [except for] indigo, which we used to have to process in fermented urine. The vendors used to bring indigo. . . .

Marcelina Callañaupa
(Chinchero)

▲▲▲

After some research and in-depth experimentation, I decided to teach the process of natural dyeing in Chinchero in 1998 to a group of women weavers who were working with the Center. Now, after continual practice, they are successfully producing intense colors.

Over the years, I've continued to give workshops in different communities that the Center works with as well as in interested communities that other organizations support. During recent years, the interest in naturally dyed colors has grown, so that its practice has expanded throughout the region. Some people have learned natural dyeing from the basic classes, others by observing their neighbors and friends. Many of the dyers can now obtain permanent colors that don't fade when the dyed cloth is washed.

Although natural dyes are healthier than chemical dyes for both people and the environment, they require much more time and are more costly unless they are made from locally gathered materials. And because excessive use of some natural dyes, such as those that come from lichens, can have a negative impact on a species, using nature's materials requires conscientious study.

▼▼▼

Some natural dyes

Q'olle (flowers), *Buddleja coriacea*, family Loganiaceae

Molle (leaves), *Schinus molle*, family Anacardiaceae

Tayanka (leaves), *Baccharis tricuneata* (Polynka) family Asteraceae

Chiqchi (root), *Berberis cliffortioides*, family Berberidaceae

Qaqa sunkha (lichen), *Usnea barbata* L., family Usneaceae

Inti sunkha, *Sticta pulmonaria*, family Stictaceae

Chillka (leaves), *Baccharis caespitosa* (Latifolia), family Asteraceae

Cochinilla, cochineal (insect), *Dactylopius coccus*, family Dactilopiidae

Mot'e mot'e (fruit), *Vaccinium floribundum* Kunth, family Ericaceae

Chaphi (branch), *Galium aparine* L., family Rubiaceae

Kinsa q'uchu or **Quinsak'ucho** (branch with fungus), *Baccharis genistelloides*, family Asteraceae

Nogal, walnut (leaves and fruits), *Junglans neotropica*, family Junglandaceae

Anil, indigo (processed), *Indigofera tictoria*, (doesn't grow in Cusco, Peru at this time)

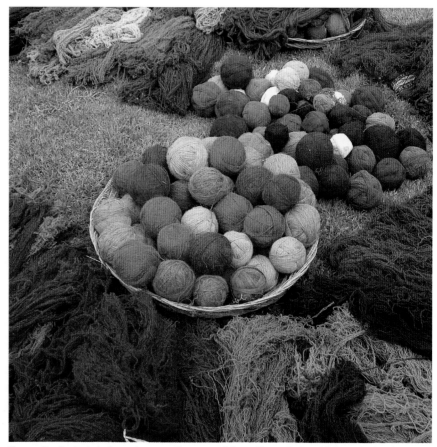

The results of a day's dyeing, using many dye pots and dyestuffs, results in a rainbow of colors in Chinchero.

Looms

The Quechua word for loom is *awana*. A loom consists of a number of different sticks and poles of different sizes, thicknesses, and finishes. As simple as most traditional looms are, it's possible to weave anything—from the simplest cloth to extremely complex, patterned fabrics. The size of the parts of the loom vary with the width of the textile to be woven.

Backstrap loom

Traditional Andean weaving is done on a backstrap loom. The design of this loom hasn't changed since pre-Incan times, except that now it may be made by a carpenter. In earlier times, the loom would have been made by a family using local trees if they were available or lumber brought in from the lower altitudes or the jungle. The backstrap loom is semi-vertical and is used to weave warp-faced cloth. Sometimes the pole opposite from the waist pole is tied to two stakes. (In the case of narrow weavings, such as straps and bands, it isn't necessary to tie the end of the warp to poles. It's just fastened with pins.) The majority of weavers in the Cusco region use a backstrap loom.

Horizontal loom

The loom is tied to four stakes called *tacarpus*. These are placed in the ground the correct distance apart to make the size of fabric desired. The weaver sits in front of the tied-up loom to weave.

For both the backstrap loom and the horizontal loom, after the loom is set up, the next step is to make the heddle and insert sticks that will assist the weaver in raising or lowering alternate threads so the weft thread can be inserted. Other sticks will hold up sequences of threads so patterns can be made.

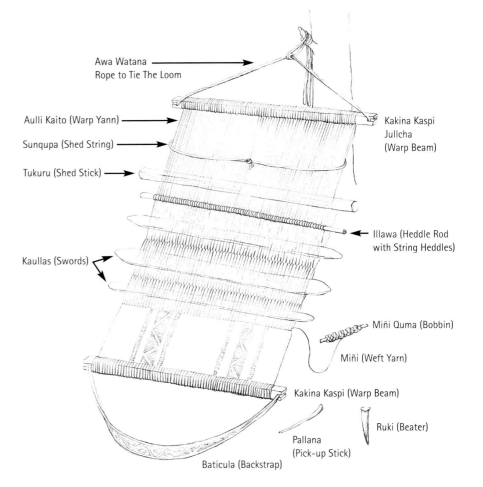

Awa Watana
Rope to Tie The Loom

Aulli Kaito (Warp Yann)

Sunqupa (Shed String)

Tukuru (Shed Stick)

Kakina Kaspi
Jullcha
(Warp Beam)

Illawa (Heddle Rod
with String Heddles)

Kaullas (Swords)

Miñi Quma (Bobbin)

Miñi (Weft Yarn)

Kakina Kaspi (Warp Beam)

Ruki (Beater)

Pallana
(Pick-up Stick)

Baticula (Backstrap)

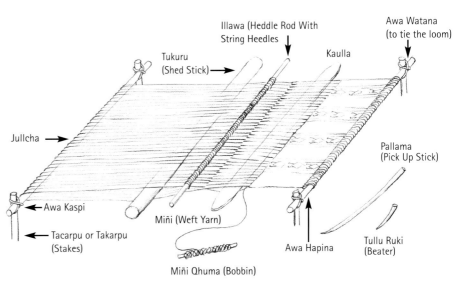

Illawa (Heddle Rod With
String Heedles)

Kaulla

Awa Watana
(to tie the loom)

Tukuru
(Shed Stick)

Jullcha

Pallama
(Pick Up Stick)

Awa Kaspi

Tacarpu or Takarpu
(Stakes)

Miñi (Weft Yarn)

Awa Hapina

Tullu Ruki
(Beater)

Miñi Qhuma (Bobbin)

Other looms

During the Incan epoch, weavers used the vertical tapestry loom. Also, weavers use a foot-powered loom adapted from Europe to produce simple fabrics used for garments such as skirts, pants, and shirts. Each community usually has only a few such looms, and men use them. Fabric of this simple type is being produced by mechanical looms in the Juliaca region.

Warping

Creating the warp consists of winding threads around sets of stakes (either horizontal or vertical). Most textiles of the Andes are warp-faced—that is, one sees only the warp threads in the finished textiles because they're packed so closely together that they conceal the wefts.

Therefore, it's vital that the warping be done correctly. Many design decisions are made while the warp is being prepared: the width, length, colors, and stripe sequences of the finished piece. Because many weavings are composed of two pieces of fabric joined together, the warp is also made in two parts.

Many weavers find that inspiration plays its largest role during the planning and warping processes. Decisions about the combinations of colors and the plain and patterned areas determine how the finished weaving will look and often how much the weaver will enjoy the weaving process, which will take many days.

Warping a backstrap loom

The groups of threads that comprise the warp

Victoria León and Aquilina Castro of Pitumarca create a warp for a small piece of weaving using the discontinuous warp technique. Creating such a warp is a cooperative effort, with both weavers contributing their thoughts about color order and stripe width.

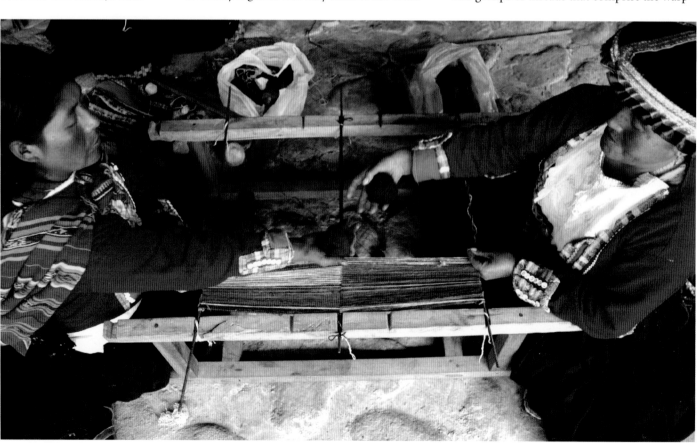

are lashed at one end to a rod, which the weaver fastens in front of her with a band that passes around her waist. The bar at the other end is fastened to a stake in the ground. The warp threads are thereby held parallel and taut while the weaver passes other threads, which constitute the weft, over and under them to create cloth.

Warping a horizontal loom

Two weavers sit facing each other, one at each end of the rectangle. They throw a ball of yarn back and forth between them, each weaver passing the ball around her stake (or around a cord attached to her stake). They pass the yarn back and forth, changing colors according to the stripe sequence they've decided on, until the warp is complete.

Not all weavers have the capacity to design well, so sometimes one needs to look for a partner who is adept at design to be one's warping companion. An experienced warping partner can also help one gain experience in creating a warp with uniform tension. The process of making the warp lasts for hours, during which the weaver and her warping partner or partners share stories about their families, their communities, and their experiences.

▲▲▲

When I was a young girl, I liked to be the warping partner because it was a good way to learn many aspects of weaving. Mothers teach their children from a young age to help warp, because a person cannot warp the loom alone.

Juana and Gregoria Pumayalli of Chinchero make a warp for a backstrap loom using the vertical method.

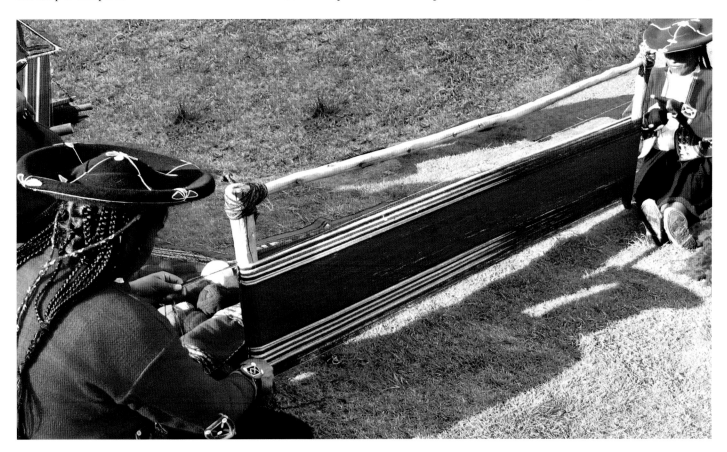

Weaving

In brief, weaving is the act of separating alternate threads, raising half and lowering half, passing the weft through, and beating the weft into place. To create a design, the weaver raises different combinations of threads. After each pass, the weft is beaten forcefully with the help of the beater, called *ruki* or *wichuna* (see illustration on page 53). In addition to the accuracy of the thread placement, the quality of the weaving is determined by the beating.

The process of weaving is a reflection of the weaver's daily life. Each of her weavings contains her own history, from the saddest to the happiest moments. Each is a manifestation of the unique experiences of her life, of her family, and of her community.

The weavers of Chahuaytire say that weaving has been primarily women's work, and the men who learned to weave often did so while they were in jail. Today, however, men are taking up the skill voluntarily. Many of the male weavers of Chahuaytire have learned to weave since they began working with the Center.

A group of weavers in the Accha Alta weaving center enjoy working together.

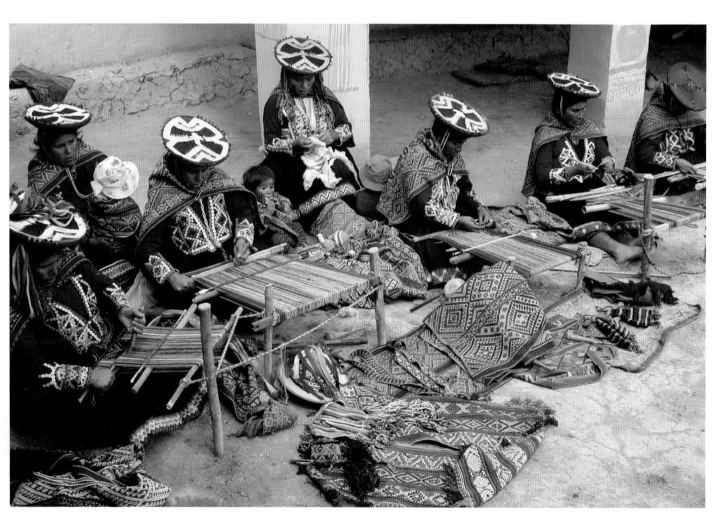

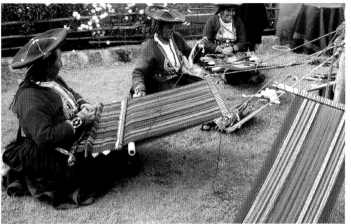

AT LEFT: Anna Espinosa of Pitumarca works on a discontinuous warp. Notice that the colors and patterns change midway through the weaving. This old technique has been recently revived.

AT RIGHT: Chinchero weavers have fun as they weave together on their backstrap looms. Weaving together is a time for sharing many things.

BELOW: A Chinchero weaver beats the weft into a long runner in shades of cochineal and indigo.

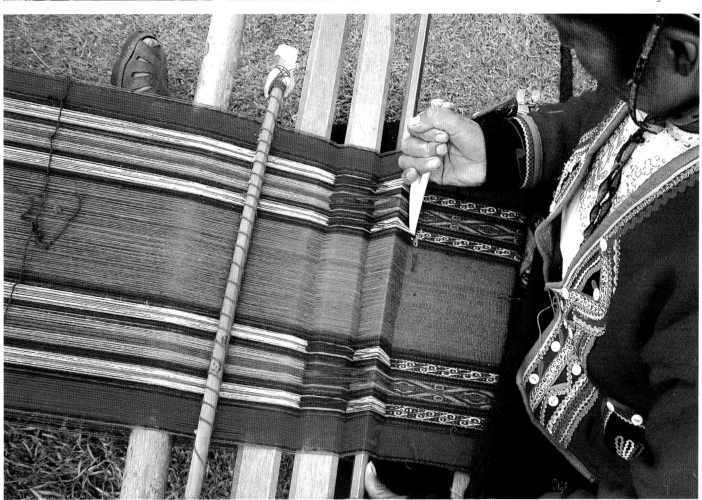

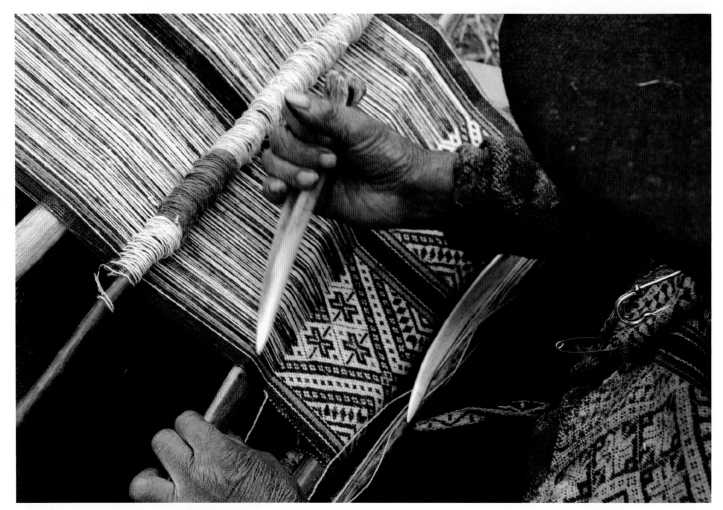

ABOVE: A weaver in Accha Alta uses the traditional llama bone beater, smoothed by years of use, to create a firm, intricately patterned fabric.

AT LEFT: The four-stake loom is used instead of the backstrap loom in some communities such as Acopia.

AT RIGHT: Men have taken up weaving in Chahuaytire, often spending evening hours after a day in the fields. The arrival of electricity has made it possible to work after dark.

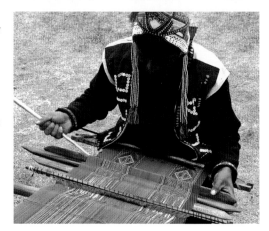

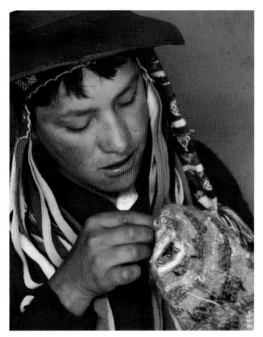
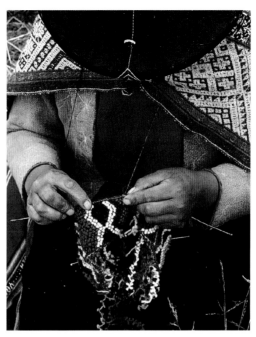

AT LEFT: A young man in Pitumarca finishes the loose ends inside a knitted *chullo*.
AT RIGHT: A woman from Accha Alta knits a baby hat with "popcorn" stitches.
BELOW: A young knitter of Chinchero plies her craft, knitting a *chullo*. Knitting was introduced to the Andes by the Spanish, and has risen to a high level of artistry.

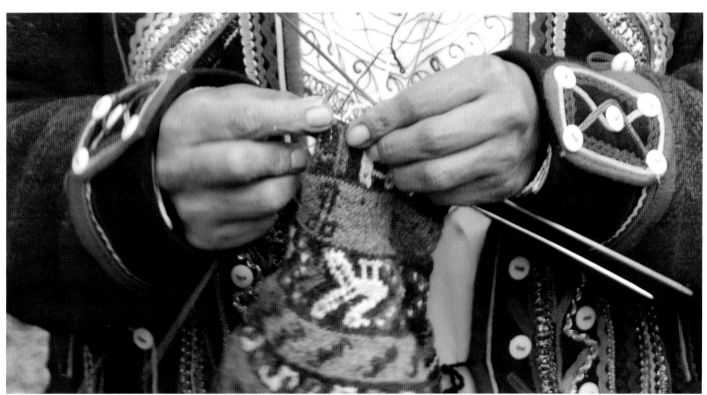

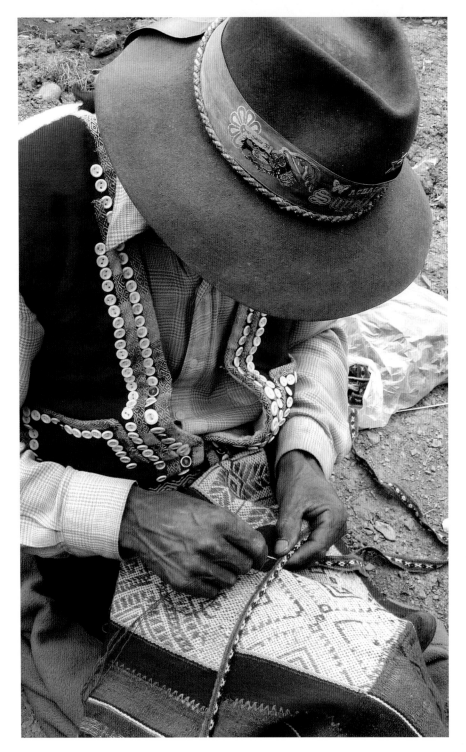

Finishing

Different procedures are used to join the pieces of a finished weaving and to finish its borders. Careful finishing can enhance a good weaving, and careless finishing can ruin it. Here are a few common joining and finishing techniques.

Chucay or *chuscay* is the sewing that joins pieces of woven cloth. The sewing can be done simply or with complex embroidery stitches that add a special decorative touch. Embroidery stitches include the *chaska* (star) or *tika* (flower) from such communities as Pisac. *Kenko* (zigzag) is a stitch commonly used in such places as Chinchero, Pitumarca, and Calca, and others.

Awapa, *chichilla*, and *senqapa* finishes are made on the edges of fabric to protect them from raveling and to add decoration. Some edge finishes are created separately and sewed on. Still others are attached to the finished piece with the weft as they are being woven.

Flecos are narrow woven bands that have color patterns in the weft. The wefts are allowed to extend past the warp on one side to form a fringe. Flecos made from alpaca yarn drape well. They're used on the edges and neck openings of ponchos.

Decoraciones are embroideries or appliqués of different fabrics applied to the joins or edges of weavings.

Remigio Pucho of Pitumarca applies a fine narrow woven band to the edge of a just-completed weaving.

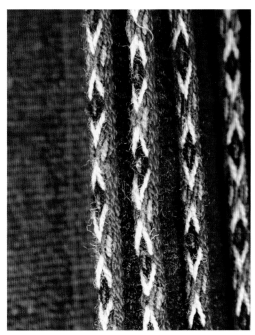

LEFT TO RIGHT: typical edge finishes from Pitumarca, and Chahuaytire. BELOW: A weaver of Chinchero creating *ñawi awapa* or *"eye border"* and applying it to the edge of a fabric at the same time. This weaving is thought to have special protective qualities.

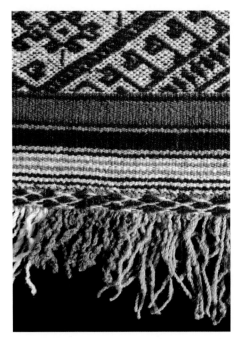 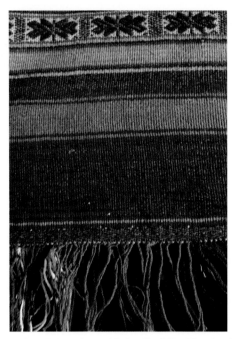 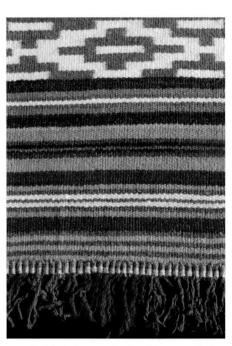

LEFT TO RIGHT: Fringes, typically used on ponchos, from Accha Alta, Chahuaytire, and Sallac. The Sallac fringe header shows the "tie dye" patterning that this community is noted for. BELOW: A weaver of Accha Alta creates a fringe for application on a poncho. As the band is woven, the weft thread is allowed to extend beyond the edge of the warp to form the fringe.

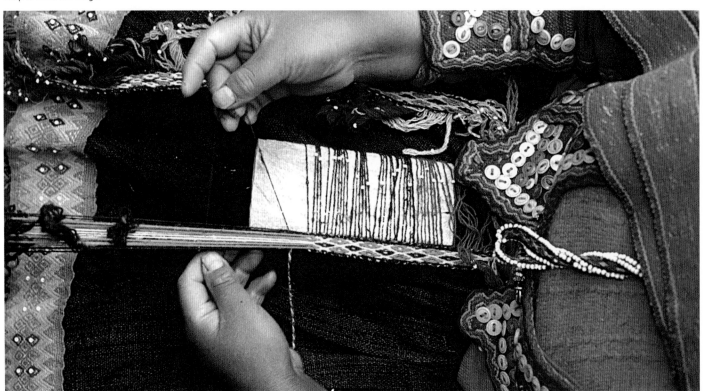

Because fabrics woven on backstrap looms are relatively narrow, panels are often joined to make wider pieces for mantas and ponchos. The methods of joining strips together are both functional and decorative. Clockwise from top left: typical joins from Accha Alta, Cchatca, Santo Tomás, and Mahuaypampa.

Cloth produced from synthetic yarns in brilliant colors has gained great favor in most communities, especially in textiles for marriages, festivals, and rituals. For young people, synthetic clothing and textiles represent honor, prestige, modernity, and youth.

We young people now wear ponchos and knitted hats made of synthetic fiber because it is more youthful; only our grandparents wear garments made of natural fiber.

Cristóbal (Ccachin)

Even my husband wants me to weave his poncho out of synthetic fiber as if he were young.

Martina (Ccachin), more than 70 years old

When I was a child, my mother dressed me in blankets made with synthetic thread, and I learned most of my weaving using synthetic yarn. But now that I have woven my manta of natural fiber, I have noticed that when I use it I'm warmer than I was with mantas of synthetic threads.

Florentina Huaman (Accha Alta)

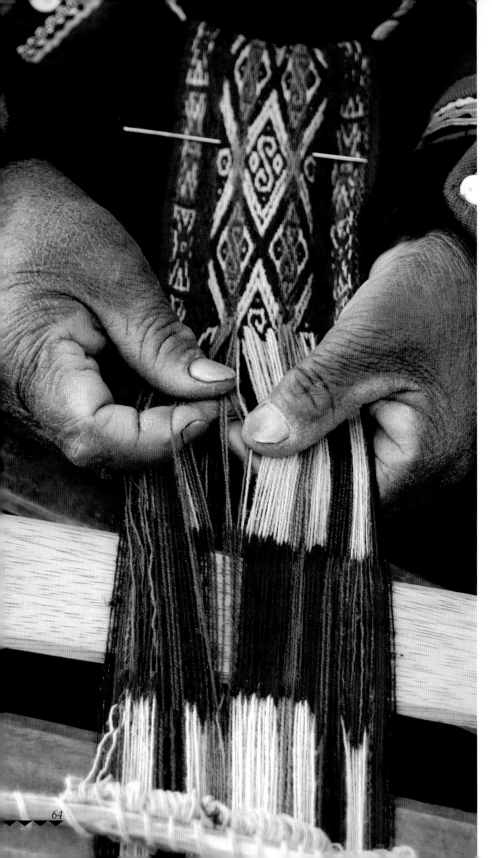

Learning Designs and Techniques

Weavers in the Peruvian Andes draw on a rich tradition of more than 2000 years. The early textiles, preserved in burial sites in the dry deserts, are astonishing in their variety and complexity. Today's weavers have retained many of the techniques and patterns from ancient times, adapting and evolving them over the centuries. Every weaving community has its own weaving patterns and techniques, which results in the great variety we see today.

Outsiders who encounter the textiles of the Peruvian highlands can't help but wonder how weavers learn the intricate hand skills necessary to do this work, or how they hold the complex patterns in their minds. Designs and techniques have been passed down through the generations without benefit of a written record, and the learning process is not formal.

Learning to weave in the Peruvian highlands usually begins when a child is six to ten years

A Chinchero weaver picks up an intricate pattern, thread by thread, in complementary warp technique.

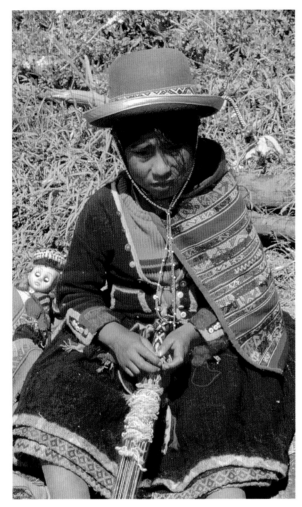
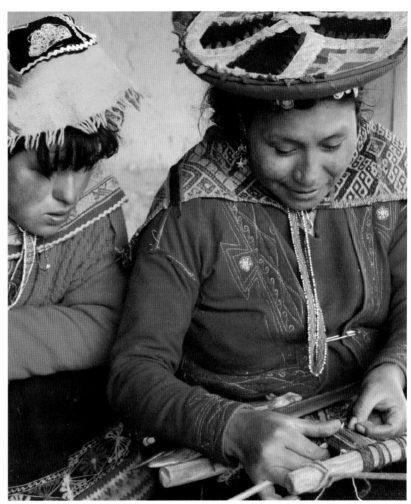

AT LEFT: A young girl from Pitumarca weaves a *golon*, or skirt border. AT RIGHT: Learning by watching is an important part of the process in mastering the intricacies of traditional pickup techniques.

of age. She begins to learn from family members, by observing each and every step of the process until the moment comes to put on her first backstrap loom, prepared by her mother, grandmother, or older sister. This first warp is only a few threads, suitable for a narrow band or ribbon. One end of the warp is fastened to a fixed object, and the other to the child's waist. The young weaver learns to understand the process, to adjust the warp and weft tension, to mend broken threads, to maintain straight edges, and to correct errors.

My mother sent my first weaving of jakima (narrow ribbon) to my older brother, who, according to custom, pitched it into the Vilcanota River and told me that after this I would weave like the river without stopping. My mother emphasized that I should learn first the design of Tanka Churo because this would bring me luck."

Guadalupe Alvarez (Chinchero)

The design called Tanka Churo is the father and mother of designs. They say that if one doesn't learn this design first, one will never learn the others.

Pilar Ojedo (Patabamba)

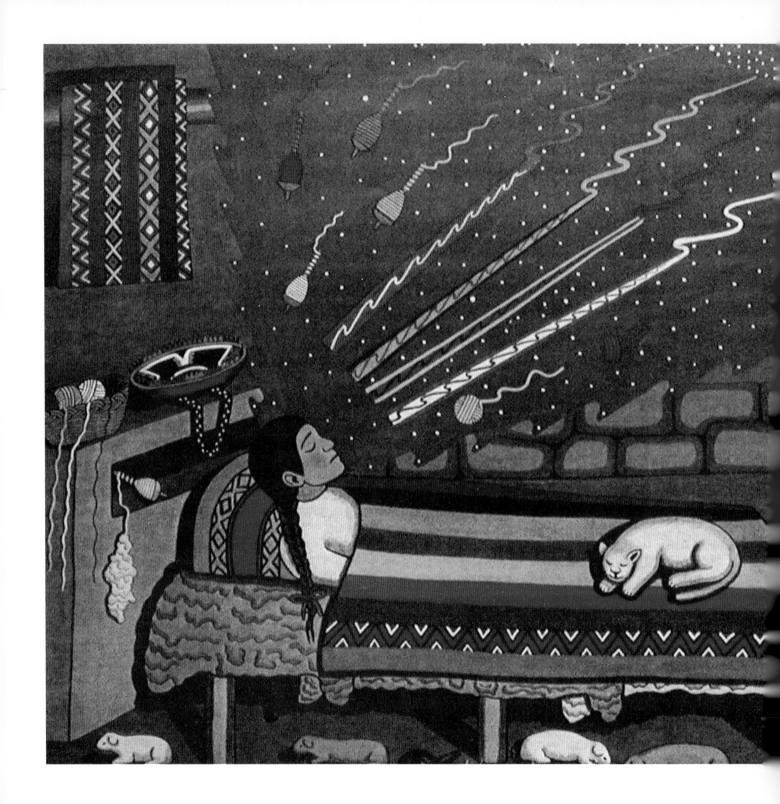

Later, a child continues her learning with short lessons and occasional assistance, but mostly by observing, experimenting, and copying other weavers. This process generally takes place during herding and grazing time, although this is changing in regions where families no longer keep animals. Though her first weavings are almost never of very good quality, with determination, practice, and faith, she can eventually become a master weaver.

Typically, a child begins with a simple pattern and weaves it until she has mastered the logic and hand skills to create it automatically. This simple pattern will become the basis of much more complex ones. If the basic pattern is at her fingertips, she can enlarge, repeat, mirror, and invert it to create larger and more elaborate fabrics.

Over time, a weaver will develop a broad vocabulary of motifs and techniques to create one-of-a-kind fabrics. Some motifs are simple geometric shapes, some are representations of plants, animals, or geographic features. Some refer to historic events or scenes from daily life; others derive from cultural or religious symbols. Each weaver holds many patterns in her mind and is able to combine them with a simplicity and harmony that belie the rich effects of her fabrics.

Understanding the basic weaving techniques can give insight into how a weaver masters the building blocks that will allow unlimited creativity. Most of the fabrics one encounters in the Peruvian highlands are warp-faced, which means that the threads running the length of the cloth completely cover the weft threads, which pass from side to side. Patterns appearing in the textiles are created as the weaver picks up groups of warp threads in intricate repeating sequences.

This painting by Angel Callañaupa vividly portrays the mystical nature of how Andean weavers receive inspiration for their work. Weaving engages the mind, sleeping and waking.

How designs grow and evolve

The ability of Andean weavers to create extremely complex patterns, and to execute multiple patterns in one piece of cloth, without written records, strikes a non-weaver as almost magical. Yet the way such designs are learned and executed has an underlying logic and systematic development, as these examples show. Patterns such as these, and even ones using different pickup techniques, can then be placed side by side to form a wide fabric of remarkable intricacy, and small patterns can become elements in wide designs.

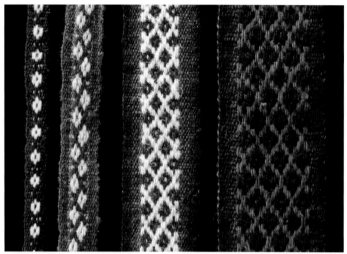

A narrow pattern can be repeated as many times as desired to make a wider pattern.

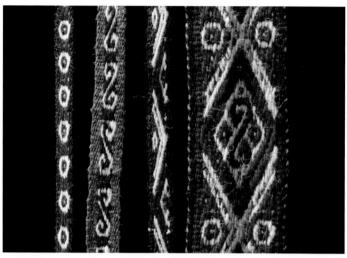

A wide, complex pattern can be created using several small motifs combined in different ways.

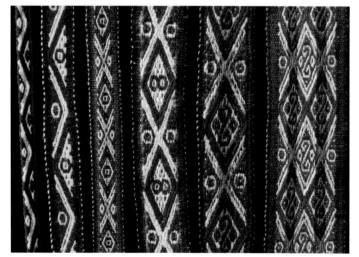

A complex pattern can result from a small motif being repeated in reverse, inverted, and mirrored in a variety of ways.

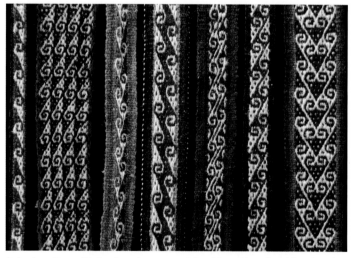

A simple pattern with few threads can grow into wider patterns by adding threads and repeating, reversing, and inverting a single motif.

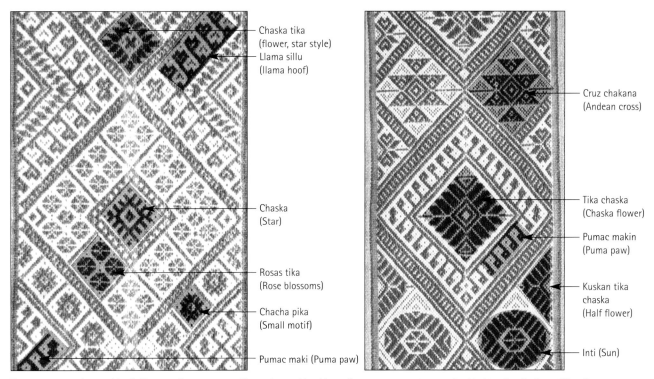

Chaska tika (flower, star style)

Llama sillu (llama hoof)

Chaska (Star)

Rosas tika (Rose blossoms)

Chacha pika (Small motif)

Pumac maki (Puma paw)

Cruz chakana (Andean cross)

Tika chaska (Chaska flower)

Pumac makin (Puma paw)

Kuskan tika chaska (Half flower)

Inti (Sun)

These two examples graphically illustrate how many motifs can be combined in endless ways to create one-of-a-kind textiles. Each motif has its own meaning, as shown in the examples on pages 76-87. Thus each textile reflects the individual weaver's knowledge, experience, and frame of mind.

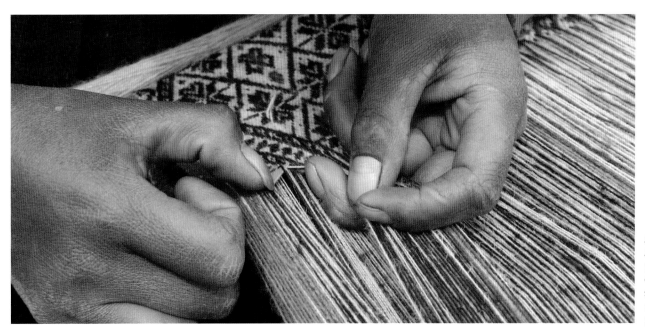

A weaver from Accha Alta picks up a complex sequence of motifs with a pickup stick.

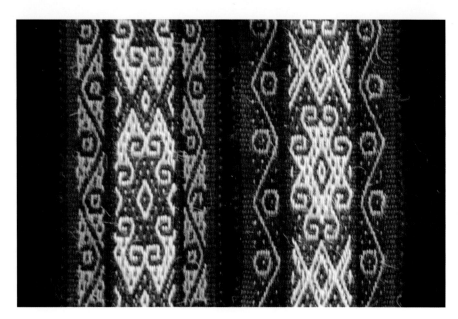

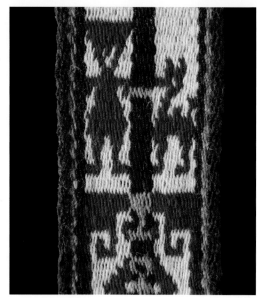

Jakira is only woven in belts, never woven in big pieces like rugs or ponchos, perhaps due to the difficulty of the technique and in addition there is a rather formidable and heavy belt that is used by young men . . . the young men use them as belts or straps when they carry heavy cargo and also to wrap up a child, especially since they are so strong.

Pilar Ojeda
(Patabamba)

Common techniques

Complementary warp technique *(urdimbre complementaria)* produces a double-faced fabric in which the pattern is the same on both sides, but the colors are opposite. In other words, if a motif is red and blue on one side, it will be blue and red on the other. Patterns are produced by picking up warp threads from the bottom layer to create a motif, at the same time dropping their corresponding warp threads from the top so that the same motif appears on the opposite side in the opposing color. This technique, which is both logical and versatile, is the one most encountered in traditional-style weaving today.

One variation on this technique is *jakira*, sometimes called "intermesh," which produces a very sturdy, thick fabric. It is used only for belts, and is practiced in the high regions around Pisac, such as Patabamba and Chahuaytire.

Another variation is *pata pallay*, sometimes called pebble weave. It is also used for weaving belts and straps, but it can also be incorporated as a pattern stripe in a wider fabric. It allows great pattern versatility and is used for pictorial motifs such as birds, horses, human forms — almost anything the weaver can imagine. Pata pallay has typically been found in Pitumarca and the Urubamba cordillera.

Supplementary warp technique *(ley pallay)* has a background warp, usually of a light color, and set of thicker warps of a darker color that create the design by floating on one face of the fabric. Only one face (the upper one as it is woven), has a clear, distinct pattern. Sometimes two pattern colors are used (called ley of three colors). This technique is less intuitive than the complementary warp technique.

Wide textiles such as mantas or ponchos often have stripes of varying widths, each combining different motifs and even techniques. Understanding a variety of techniques and having mastery of many patterns makes it possible to create whatever design one wants using the basic principles of pickup weaving.

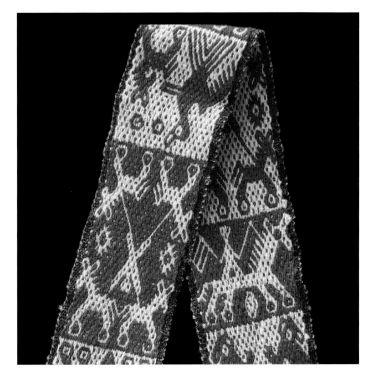

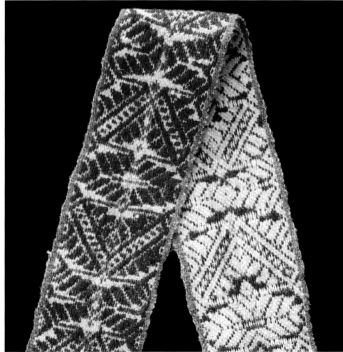

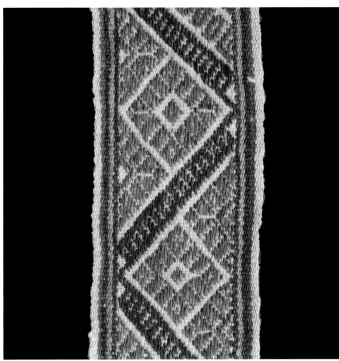

UPPER LEFT: This band uses *pata pallay* technique, also called pebble weave. The technique lends itself well to pictorial motifs, as shown here.

UPPER RIGHT: Two sides of a band woven in Accha Alta using the supplementary warp technique in two colors. Note the long warp threads on the face that form the pattern.

LEFT: A band in three-color supplementary warp technique from Pitumarca. Keeping track of which warp threads to raise to form the pattern is more difficult in this technique than in complementary warp or two-color supplementary warp techniques.

It is very difficult to choose the threads which make the pattern of a three-color design [in ley pallay] because one must be thinking about which color is creating the design on the top of the design, and which color is making the design on the bottom

Genoveva Choqué (Pitumarca)

I don't like ley pallay for my weavings because . . . it has only one face and one has only one side of the weaving that can be used face out

Pilar Ojeda de Kille (Q'engo)

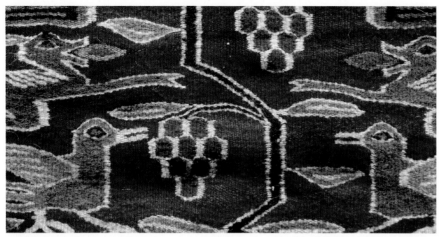

Detail of a tapestry woven in Pitumarca.

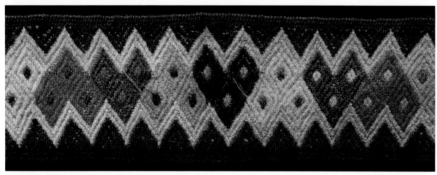

A skirt border in *golon* technique from the Pisac region.

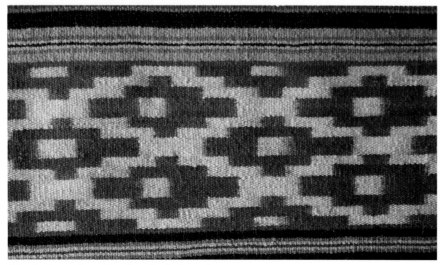

A tie-dyed, or *watay*, pattern from the Ccatca region.

Weft-faced weaves

Tapestry *(tapiz)* is an ancient technique in which different colors of weft completely cover the warp to create patterns. Remarkably fine examples dating from pre-Columbian times can be seen in museum collections. A style which dates back to Colonial times has been taken up by men in the Pitumarca region. They produce decorative works that often include pictorial motifs such as animals, plants, and the like. The village of Ayacucho has been producing large, coarse tapestries suitable for rugs and blankets as well.

Golon is a twill tapestry weave done with multiple heddles for raising the warps. It is used to produce *golones*, the narrow bands used to decorate skirt borders. Golones are usually brightly colored with geometric patterns. The warp is a solid (usually light) color except for the edge threads, which are of a contrasting color.

Other techniques

Discontinuous warp *(ticlla or kuchu)*. The majority of the weavings in Cusco are created from one long, continuous warp. In Pitumarca and Q'eros, however, weavers still practice an ancient technique in which the warp threads change colors along their length. Sometimes the resulting fabric has simple color blocks, but other times the result is intricate patterned stripes that change midway through the weaving. In Pitumarca, small fabrics made up of four color blocks—usually natural-fiber colors —are used for making ceremonial offerings. Sometimes the warp is discontinous, and sometimes the weft.

Tie-dyed warp *(watay)*, a special technique dating back to pre-Incan times, known as ikat in some cultures, is less common. When acrylic yarns became popular, this technique largely disappeared, because the acrylic yarns couldn't be dyed. A narrow warp, usually white or an-

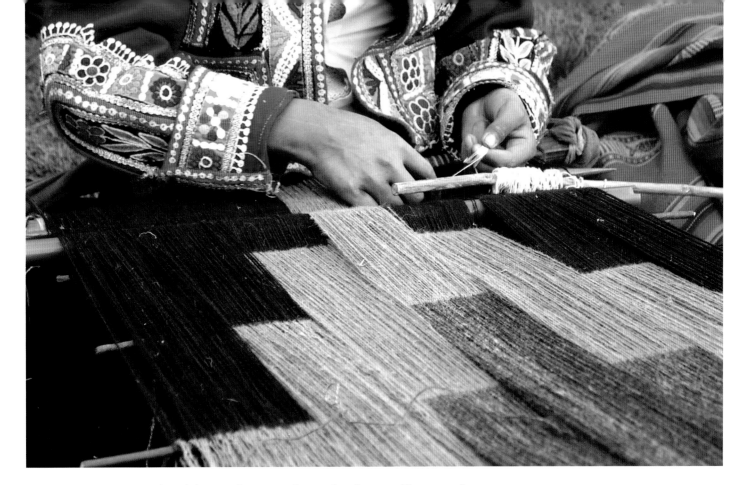

A weaver in Pitumarca works on a discontinuous-warp fabric. This ancient technique results in warp-faced fabrics that change color along their length.

other light color, is created, and then sections of warp threads in both the upper and lower layer are bound tightly in a pattern. The warp is then dyed, but the bound portions retain their original color. After being washed and dried, this section of warp becomes part of a larger warp with other colored stripes in a manta or poncho. As the whole warp is woven in a plain over-under sequence, the dyed pattern in the *watay* portion appears automatically. Most weavings done in this technique have geometric patterns, though it is possible to create more intricate motifs such as names and dates.

A special textile that is disappearing is the *wasa watana* – a decorative ribbon with other ribbons woven across and through it. The main band is partially woven, and then other warps inserted and woven. These are often very elaborate, and used as hair ornaments or on dancing hats.

Another special textile, not commonly seen, is the *chuspa con unan niyuc* – a coca bag with a woven-in pocket which holds the mineral lime which is chewed along with the coca leaves. You can see an example of this on page 38, upper right hand image. The warps are longer in the area where the little pocket is made. When the weaver reaches the spot where the pocket will be, she weaves only the longer warps for the length of the pocket. When the pocket is complete, she pulls the tab of fabric down so that all the remaining warps are the same length before continuing to weave the bag.

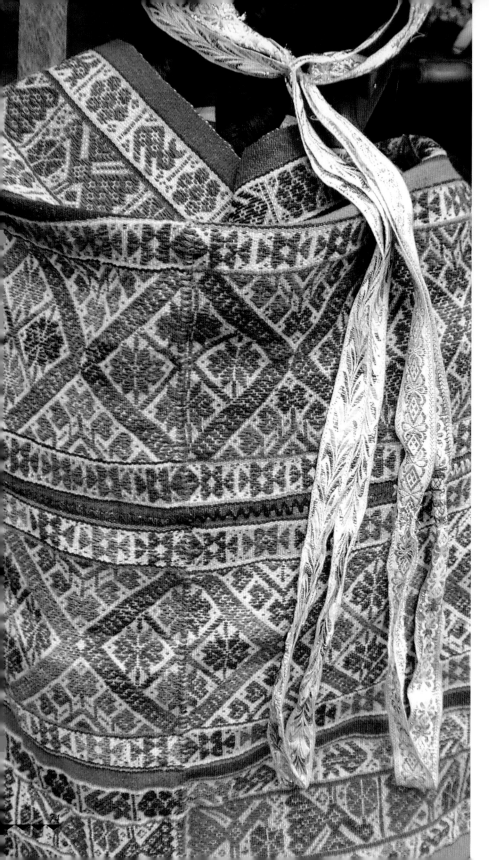

Names and Meanings: Patterns of Life

The information in this chapter is the result of many interviews conducted over the past decades with weavers of different ages in the Cusco region, but especially the older ones. We have been able to document different techniques and designs in those communities where the Center sponsors weaving groups, as well as in some other communities whose weaving has unique characteristics.

We have collected this information through the voices of the weavers, and have found great richness and variety of designs in each region – but also many questions. Some design concepts are difficult to convey in language, and many ambiguities exist. So this account only includes designs that represent something tangible and are named accordingly.

My intention in this chapter is not to interpret the designs, but simply to pass on the information I have acquired throughout these years from the weavers of Cusco. Other researchers,

A woman from Pitumarca wears a ticlla of many supplementary three-color designs.

both from Cusco and other parts of the world, have published work that can shed light on this subject. A partial list of these resources can be found on page 106.

Many of the designs that one sees today in the weavings of Cusco are very similar to those of pre-Incan, Incan, Colonial, and Republican times. Some have been created in the recent decades, inspired by the weavers' personal history, and by the natural and social world that surrounds them. The result is an almost limitless number of designs, ranging from simple to complex, with color variations and combinations of motifs adding to this rich pattern vocabulary. And although some of the meanings of the designs have been lost, their use still persists. You will find elaborate patterning particularly evident in the work of the unmarried men and women who have more time to devote to their work, and in the clothing and fabrics used for festivals, weddings, and other ceremonies.

In spite of the all the social changes that have occurred in the Andes, textiles continue to fulfill important functions in the life of the weavers. They are used as special gifts for important people (as when the president or other dignitary visits a region). And they have economic importance beyond the income they bring to individual weavers. Weaving continues to play an important role in rituals—even in death.

Different localities have named designs that are peculiar to that place, and in many cases the same designs acquire different names in different places. Also, some kinds of designs are woven only in specific textiles in some places, such as belts, skirt borders, jakimas or watanas (small belts), and colored mantas that are worn only with contemporary, non-traditional clothing.

The possibilities are endless. A design can represent an object, an animal, a person, an abstract concept, or an event. It can be represented partially or in its totality. For example, a flower might be shown as a whole blossom, or as only a portion of one. It can be viewed from the side, from above, or below. The only limit, really, is the imagination and vision of the weaver.

In the creative process, the weaver is constantly thinking of designs and combinations of designs to weave, whether for a special occasion or for sale. Sometimes the weaver has a dream that inspires a design or combination of designs. When it is time to create the warp, the weaver will have a clear idea of what the finished work will look like. This vision is held in the weaver's mind, not recorded on paper. Always, a design issues from the weaver's heart and soul, and the resulting fabric is a reflection of his or her emotional state.

Natural zig-zag erosion lines are echoed in many weaving patterns.

When I'm asked about the meaning of the designs, I say, "I too would like to know the meaning of all of our patterns, but since my mother was not a weaver, she did not have any interest in obtaining the information from my grandparents. The little that I know is from other old weavers "
 Reyna Fernandez (Pitumarca)

I can sell my weavings quickly due to their designs and high quality and in addition the authorities always request my weavings for their events. I can't make very many because they require a lot of time
 Celia. Callo. Pitumarca

I don't understand how I came to use these colors in my design. It would be understandable if I had been working in the dark
 Delia Sallo (Chinchero)

My head I think has given a turn to the negative side . . . I don't understand how I could make so many errors.
 Pascuala Messco (Chinchero)

Agriculture. Since agriculture has always been the principal economic activity in the Andes, many of the textile designs represent fields, landscapes, and traditional farming implements, which have changed little over the centuries.

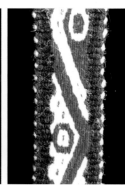

Q eswa – Rope made of *Quya* (a very strong Andean grass). Chinchero. It inspires the pattern on the right.

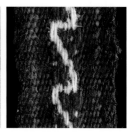

Taclla – A single bladed plow pulled by oxen.

Taclla qénqo – Zigzag pattern which represents a single-bladed plow.

LEFT: Agricultural terraces are seen throughout the Andean highlands, and have influenced the creation of many weaving patterns, such as this skirt border.

Astronomy. The dark, starry skies of the Andean highlands have been studied and appreciated by the people since time immemorial. Even today the position of the moon and the stars is very important in the life of the country folk for planning when to plant and when to harvest. Representations of the stars, constellations, sun, and moon are common in textile designs.

Inti — the sun, and the principal sun god of the Incas — is venerated even today in many rituals. Weavers represent the sun in their designs according to their perception and according to the technique or skill that permits them to create it.

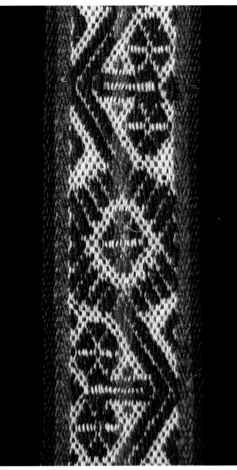

To greet the dawning of San Juan Day (the 24th of June), we have the custom of climbing to the top of the highest hill or mountain and we wait for the sunrise. If you are lucky enough to see t'ata inti (double sun) at the side, you will be able to see your wishes. I once had the wish of having a lot of sheep and this wish was fulfilled because I saw the t'ata inti and at the side, many sheep. So in our patterns we sometimes make the t'ata inti.

Damiana Huamán.
(Chahauytire)

Mayu inti is the representation of the reflection of the sun in the water, or so we heard from our grandmothers.

Juana Puma (Accha Alta)

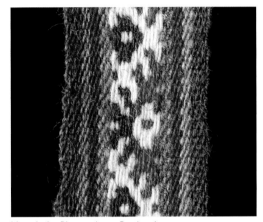

Mayu inti – River and sun. Patabamba

Mayu inti – River and sun. Chahuaytire

Mayu inti is the constellation that one sees at night in the sky and the half round is the representation of the sun. It would be possible to say representation of night with the mayu and of day with the sun.

Damiana Huaman
(Chahuaytire)

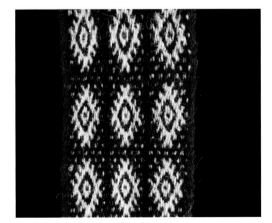

Chaskas – Motif of stars. Chumbivilcas.

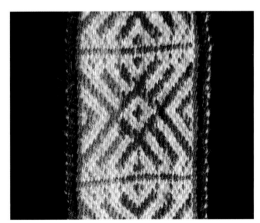

Chaska – Star motif. Pitumarca

Flora. Flowers, leaves, fruits, herbs, seeds – all play a part in daily life and are represented in textiles.

Rose blossom.

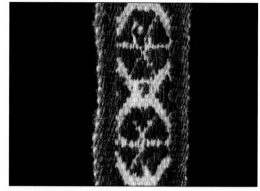

Rosas tika - Rose flowers. Accha Alta.

I like to weave designs of flowers, especially using three colors, because it makes my weavings very colorful and one can see my designs from a distance.
Rosie Copara
(Pitumarca)

Potato flower.

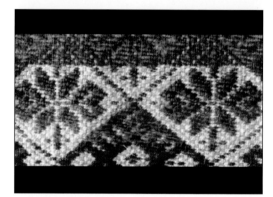

Papa tika – Potato flower. Patabamba.

Flower design are more than anything for young people so they are like flowers and very visible.
Paulina Cjuno
(Pitumarca)

Añu flower.

Añu tika – Flower in the Tripaelacea family, Tropaelum uberosun. Patabamba.

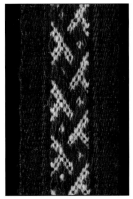

Kallma ley – Branches made in the supplementary warp (ley) technique. Patabamba.

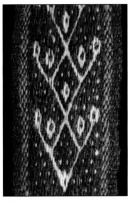

Kallma tika – Branch with flowers. Patabamba.

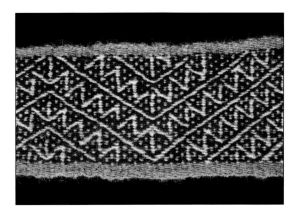

Nut'u raphi – Small leaves. Chumbivilcas.

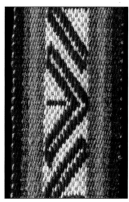

Sara raphi – Corn leaves. Sallac.

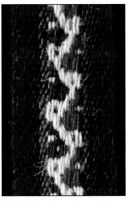

Cirisuelo – Type of weed found in wheat fields. Patabamba.

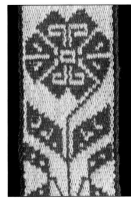

Tika – Flower. Chumbivilcas.

Tika – Flower. Chinchero.

Tika – Flower. Pitumaca.

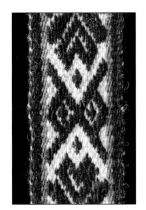

Tika ley – Flower in ley technique. Chahuaytire.

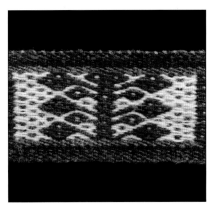

Pultay tika – Pultay flower. Patabamba.

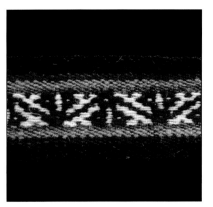

Kinray tika – Flowers arranged horizontally. Pitumarca.

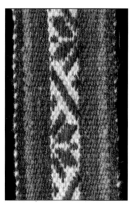

Kuskan tika – Half-view of a flower. Sallac.

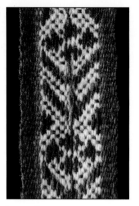

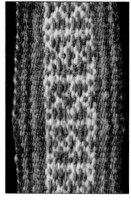

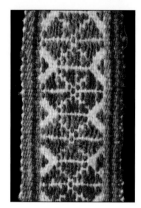

Ramo tika – Bouquet of flowers. Sallac.

Una tika – Small flower motif. Sallac.

Rosas – Roses. Sallac.

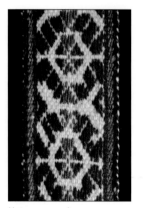

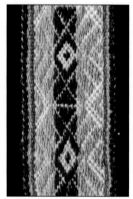

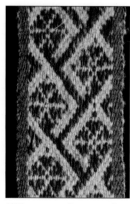

Hatun rosas – Large roses. Sallac.

Jautay rosas – Handful of roses. Pitumarca.

Wiñac rosas – Roses growing. Accha Alta.

Raki raki – a type of bromeliad. Chinchero.

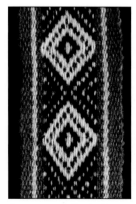

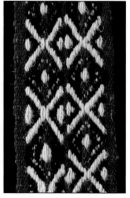

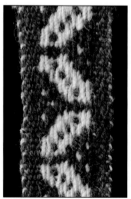

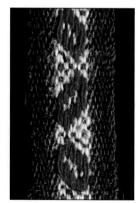

Durazno ruru – Peach pit. Chumbivilcas.

Tinki duraznos – Two peach pits side by side. Chumbivilcas.

Pacay – Pacay fruit. Accha Alta.

Pacay ley – Pacay fruit, in ley technique. Patabamba.

Fauna. While some weaving patterns represent an entire animal, such as a horse or a deer, more often an animal is represented by a stylized part, such as a hoof or claw.

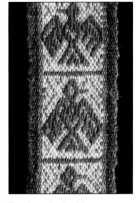

Condor – Accha Alta.

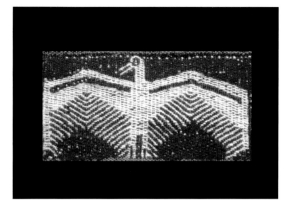

Condor – Choquecancha.

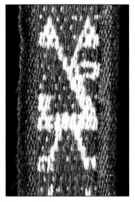

Deer – Mahuaypampa.

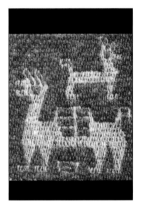

Llama – Ccachin.

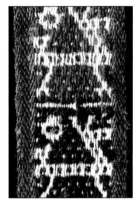

Llama – Patabamba.

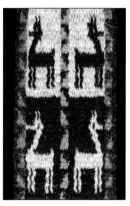

Llamas – Patabamba.

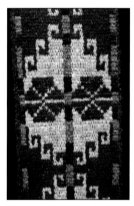

Pumac maqui – Puma's claw. Patabamba.

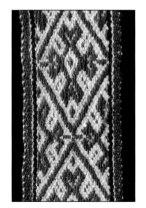

Puma sillo – Puma's claw. Accha Alta.

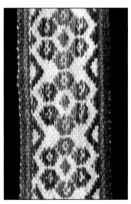

Pumac yupin – Puma footprint. Ccachin.

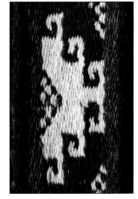

Kuskin pumac maqui – Half a puma's claw. Patabamba.

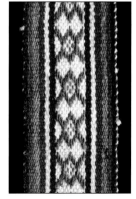

Araña – Spider. Sallac.

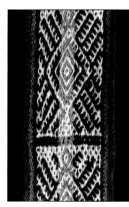

Araña – Spider. Patabamba.

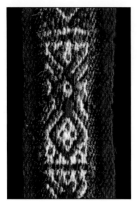

Araña – Spider. Patabamba.

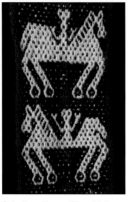

Caballo – Horse. Chumbivilcas.

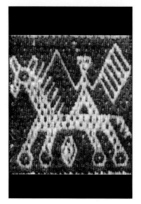

Caballo – Horse with man and flag. Cchacin.

Challwac huactan – Fish rib. Chinchero.

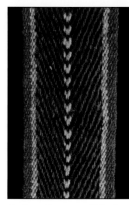

Challwac huactan – Fish rib. Chumbivilcas.

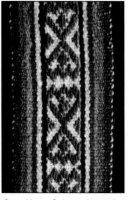

Cuye kiru – Guinea pig teeth. Sallac.

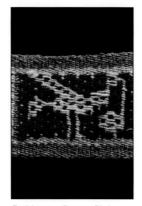

Espiritu con flores – Birds carrying flowers. Pitumarca.

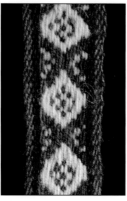

Huacac ñawi – Cow eye. Mahuaypampa.

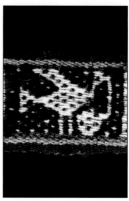

Q'enti – Hummingbird. Pitumarca.

Siwar q'enti – Large type of hummingbird. Pitumarca.

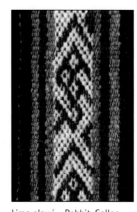

Lima q'owi – Rabbit. Sallac.

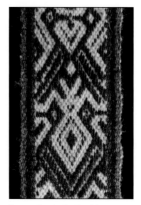

Pato – Duck. Accha Alta.

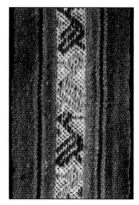

Patos – Ducks. Sallac.

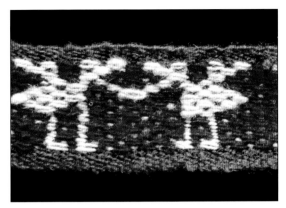

Pato – Duck. Mahuaypampa.

Pichinchus – Birds. Chumbivilcas.

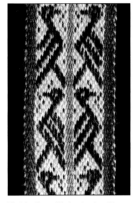

Pichinchus–Birds. Accha Alta.

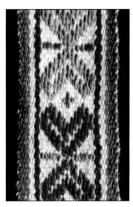

Pilpinto – Butterfly. Sallac.

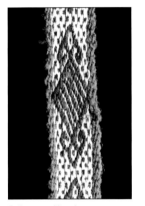

Qalaywa – Lizard. Chumbivilcas.

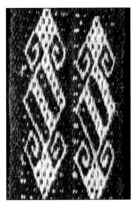

Sinpà qalaywa – Braided lizards. Chumbivilcas.

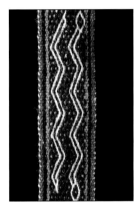

Snakes – Chinchero.

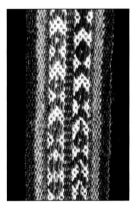

T'ata challwa – Fishes together. Sallac.

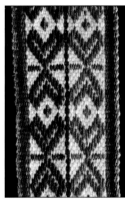

Truchac chupan – Tail of a trout. Sallac.

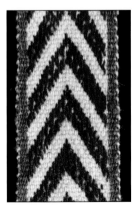

Truchac huactan – Rib bones of a trout. Sallac.

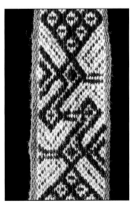

Uminakuj espiritucha – Birds sharing food. Huilloc.

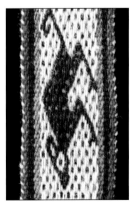

Viscacha – Rodent similar to a chinchilla. Chinchero.

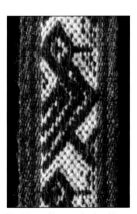

Urpicha – Pigeon. Accha Alta.

Human forms. People are represented in literal ways or symbolically.

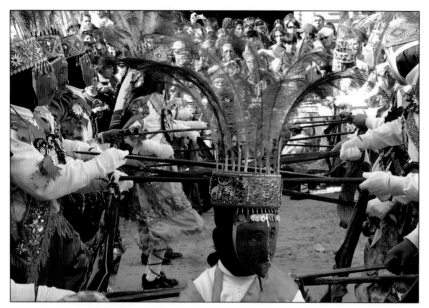

Chunchu – Jungle dancer. Q'eros.

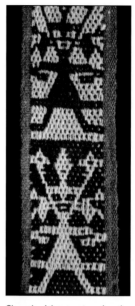

Chunchu iskaymanta – Jungle people using two colors. Pitumarca.

Inka – Representation of the Inka. Ccachin.

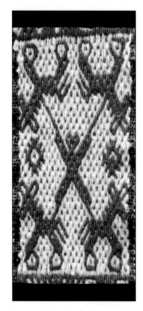

Descuartizacion de Tupac Amaru – Depiction of Tupac Amaru being drawn and quartered.

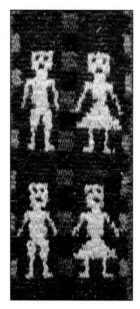

Warmi kari – Man and woman. Patabamba.

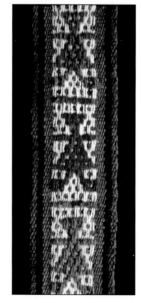

Pasña – Girl. Patabamba.

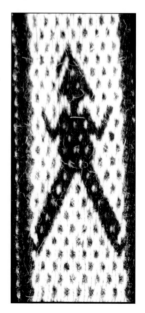

Q`ari – Man. Chinchero.

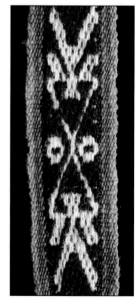

Runa tika – Men holding flowers. Mahuaypampa.

Water. This vital element for sustaining life is represented in weavers' designs in many different ways.

A winding river motif is used in many woven designs.

Two lakes above Chahuaytire. The lake design (at right) is abundant in this region.

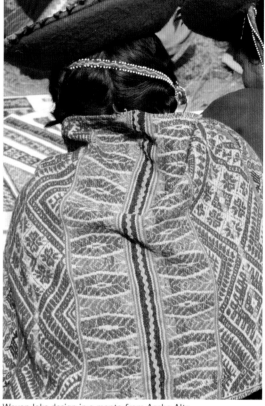

Woven lake design in a manta from Accha Alta.

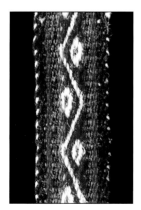

Mayu q'enqo – River in a zigzag pattern, as they sometimes appear in the high Andean valleys. Chinchero.

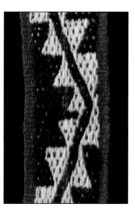

Mayu q'enqo – River in a zigzag pattern. Chumbivilcas.

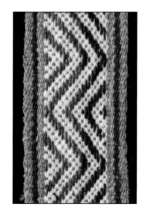

Mayu q'enqo – River in a zigzag pattern. Pitumarca.

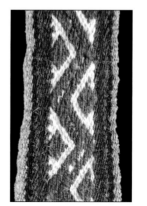

Mayu ley – River in ley technique. Patabamba.

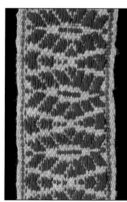

Lagos – Lakes. Accha Alta.

Geometric designs. Often simple geometric forms are used in weavings for their own sake, not as symbols of other objects. Rhombuses, crosses, lines, curves, zigzags, rectangles, and stripes are common examples.

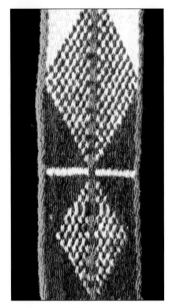

Rombos – Rhomboid shape. An elongated parallelogram.

Cocos (rombos) – Rhombus. Pitumarca.

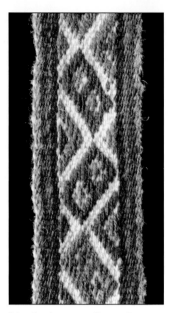

Iskay ñawi organo – Geometric representation of eyes. Sallac.

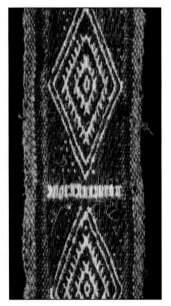

Loraypo – A combination of patterns in which geometric shapes stand out. Patabamba.

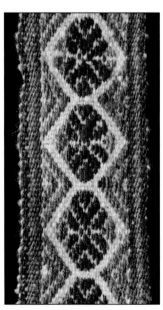

Mayo puyto – An example of geometric shapes. Sallac.

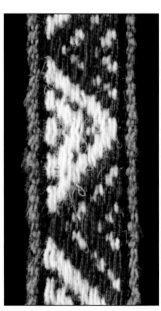

Puntas – Representation of hills and mountains. Mahuaypampa.

Common objects. Everyday objects are sometimes depicted in weavings. They can be represented in a literal or in a symbolic manner.

Many years of study suggest that the names of designs don't always have a clear meaning in Quechua. This could be for several reasons. Perhaps they came from languages other than Quechua, or perhaps the names have been modified in the course of our history. Or weavers of recent generations have not understood that a design has been modified and has acquired another name. Finally, some names refer to the technique of making the design rather than referring to a physical object.

Moreover, young people ultimately only copy the designs of other weavers, which means that the information about names and origins that could have been acquired from older weavers is lost. And if truth be told, sometimes one hears a very philosophical explanation that is given simply to satisfy the listener.

Another fact that has created confusion in the naming of designs in recent years is that many weavers have lost interest in the original identity of the designs and of the different places from which they came. Many weavers are using designs that are not indigenous to their locale, either because they like them or because they are motivated by their commercial value.

As a weaver, I was lucky to have my first lessons from my mother, who told me about the many experiences of the weavers of her generation. She also related stories of my grandmother, who was a marvelous weaver who spent her widowed life weaving and supporting her family with it. So it was that I learned that the design called *tanka churo* should be learned first, because it is the mother of all the designs and it would bring me luck.

Many people — students, foreigners, weavers from other countries — come to me asking about the significance of the designs. Sometimes I have said that I don't know, but at other times they have brought me examples and I have consented to give an opinion, but no more than to agree or disagree, and depending on each case, and only if I had the time or patience.

Marcela Callañaupa
(Chinchero)

The patterns of Chinchero can be seen in many weavings of regions other than Cusco, in other communities as well as in other countries, and perhaps as a consequence of this our identification with our patterns in the future could disappear, since one sees this phenomenon in textiles that are for sale and not for the weaver's own use.

Estefania Quispe (Chinchero)

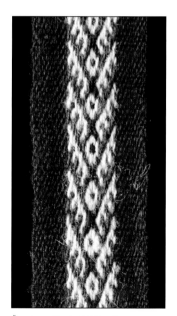

Ñaccha – Comb. Patabamba.

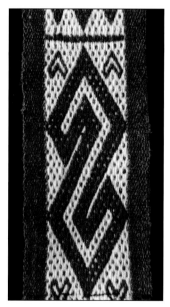

Romana – Manual scale used to weigh agricultural products. Patabamba.

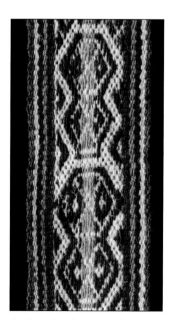

Tumin tumin – Large ceramic vessels for storing chichi (corn beer) and other liquids. Sallac.

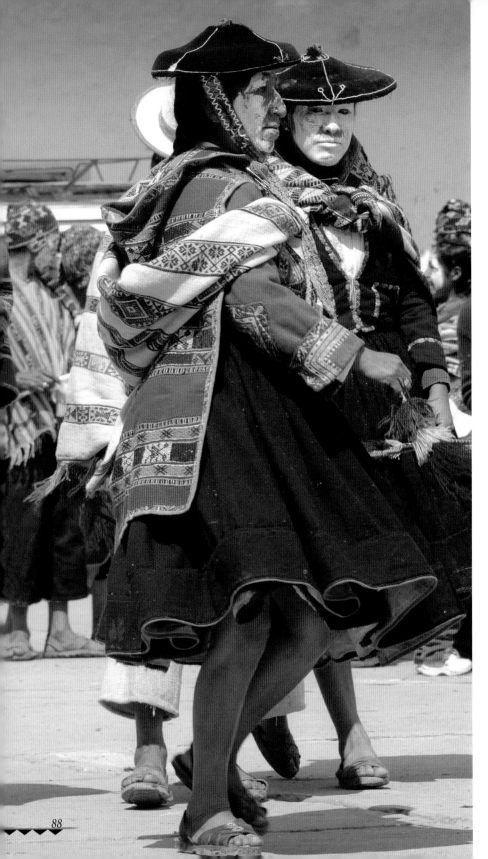

Textile Traditions

Traditional Andean weaving is deeply embedded in the culture of daily life. Beliefs and superstitions built around weaving are passed on orally from one generation to the next. Even though the place of textile production has diminished in recent decades because of changes in religious beliefs, loss of language mastery, and technological advances that change the way people live, the cultural thread remains to tie people to their weaving heritage.

Beliefs and superstitions

Customs and beliefs form a fundamental part of the world of the weaver. In some case they provide psychological incentives for continuing to weave; in other cases they serve as excuses or explanations for situations that arise during the weaving process.

Dancers in Pitumarca during Carnaval. Roman Catholic traditions blend with native rites in many traditional festivals and rituals.

It is bad luck for a hen to walk over the top of a warp, because it will then be difficult to finish the weaving. The hen, it is said, is looking for food by scratching the earth with her feet, just as the weaver will scratch at the warp for a long time with little result.

Rosa Quispe (Chinchero)

If a person enters into the place where someone is making her warp, that person has to go get a rock and put it beside the balls of yarn that are being used for the warp. This ensures that there is enough yarn to finish the weaving, plus enough for another weaving.

Aquilina Castro (Pitumarca)

This suggests the importance of the threads; a lot of time is invested in spinning them, and the weaver wants them to last for many weaving projects.

When I was a young girl, my mother didn't want us to eat next to where she was warping, because it was bad luck. It was like eating the threads that were being used for warping, and as a consequence of this there wouldn't be enough threads to complete the warping project.

Pilar Huaman (Patabamba)

Ever since I was a girl I knew that I could not weave nor spin on Sundays and holidays because my weaving would suffer some misfortune. It might be lost or burned, or some other bad would befall it. I have observed this belief, even through my old age.

Marcela Callañaupa (Chinchero)

A pregnant woman could not make skeins of wool nor weave because it was believed that the umbilical cord of her child would wrap itself around its neck in the womb.

Nieves Quispe (Accha Alta)

In Chahuaytire we sometimes spin to the left [counter clockwise] and we call it lloque. We use the resulting yarn in various ways. For example, pregnant women tie it to their ankles and waist so that this thread will protect them from bad desires, bad winds, and such. Also, we put these threads around the necks of new-born animals to protect them. In the same way, we use stripes of threads twisted to the left and ones twisted to the right in the warp of some of our weavings, especially in the borders of our mantas so that the corners won't curl. Moreover, this prevents bad energy from being received through our mantas. Although, now the younger generation no longer believes much in this because they receive health service from itinerant doctors.

Pascuala Quienaya (Chahuaytire)

When I was young, to request the hand in marriage of a young girl, one needed to wear a shawl with a plain red background, and later to wear it dancing to the house of the parents of the groom.

Marcela Callañaupa (Chinchero)

When I got married my parents gave me animals and in gratitude for this I made a type of fiesta with my neighbors. With my neighbors we brought food and drink to their house and later, in the afternoon, we brought them back to my house dressed in mantas and dancing to music. We also did this in order to have good luck with the rearing of my animals

Pilar Ojedo(Q'enqo)

Rituals and festivals

In the Andes, numerous ceremonies and festivals are celebrated during the year, and the Andean calendar many times coincide with Catholic festivities. The Andean divinities and the Catholic ones are related in respect to fertility, and agrarian productivity and domestic animals. The important ceremonies occur during the time of Carnaval (the week before Lent). Its festive character ensures the

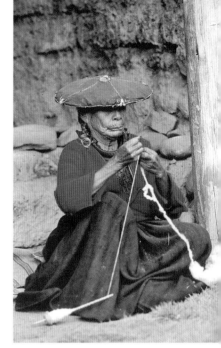

Emiliana Ccana an elder teacher of Pitumarca, spins at age 85.

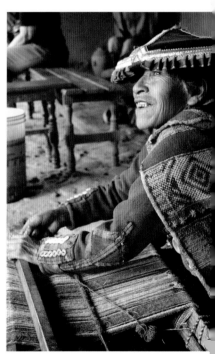

Nicolasa Suyo, another elder of Pitumarca, tying her loom.

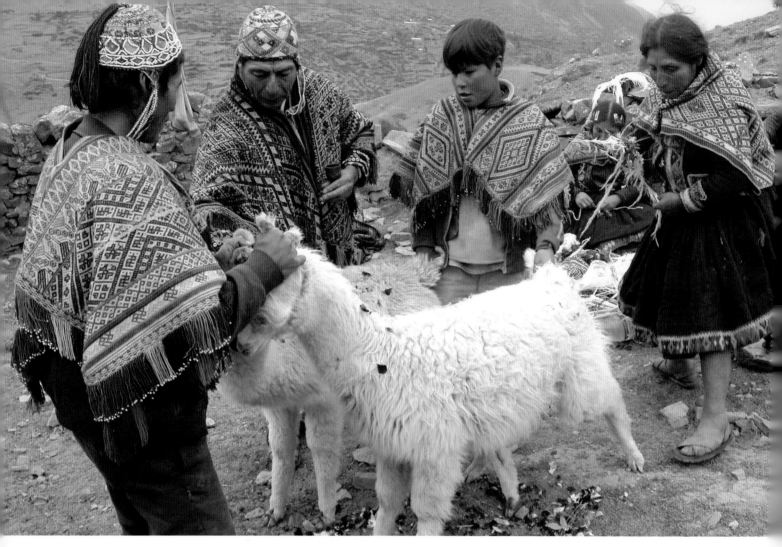

Simeon Gutierrez and his family perform an alpaca fertility rite in Accha Alta.

participation of young people. They begin with ceremonies for the families' domestic animals. It continues with community and inter-community celebrations.

The most commonly practiced indigenous ritual in Andean culture is *Haywarisqa*. This ceremony invokes the Quechuan deities that inhabit sacred places — the mountains, the earth. This ceremony can be used for better health, for the well-being and fertility of animals, for exorcising bad luck, or for counteracting sorcery. The ceremonies are conducted by Andean priests known as *paqo* or

altumissa. They make appeals to the Apu, the Pachamama and other major Andean dieties. Offerings contain elements of animal matter, vegetable matter, mineral and industrial matter. In the past, people wove special delicate, colorful fabrics that they buried or burned with their offerings. The ceremonial weavings serve to define a sacred space over which the sacred objects are arranged. Today, these special fabrics have been replaced in most cases with pieces of paper.

Many familes have *missa q'epi*, ceremonial bundles in which they keep their sacred

objects, amulets, ropes, and antique weavings of their grandparents. These bundles are kept in special places in the house. They are unfastened during ceremonies, on pre-determined dates. They may also include small weavings for amulets or coca leaves. The textiles vary from from family to family, depending on what they have inherited.

In some places, such as Pitumarca, they use *tiqlla unkuñas*, special weavings comprised of four colored squares. Offerings are placed on each square so that four offerings can be made at the same time.

Now, those who have converted to another religion like Evanglicals are throwing the q'epis in the river or are selling them because they no long believe in these customs.

Honorato Quispe (Pitumarca)

During the year there are ceremonies called Uywa Chuyay, *during which animals are venerated. The ceremony for cows is in August; for burros, at Saint Ramon at the end of August; of alpaca . . . during Carnaval . . . For this ceremony we prepare* phiri *(a type of corn flour mixed with sugar water flavored with chamomile or cinnamon), that during the ceremony is eaten on top of weavings without spilling any on the ground because that would bring bad luck. If one wants gray-colored fiber, one must prepare the* phiri *out of corn of this same color; if one wants white fiber, the* phiri *must be prepared from white corn.*

Hilaria Copara (Pitumarca)

The *Mojonamiento*, an annual ritual held on Friday before Carnaval Sunday, is a ritual mix of pilgrimage and footrace. All the men from the community run, with the elderly running only the easy parts. It is a special obligation of the *embarados*, the group of four to six men who are elected in each community to perform certain leadership functions for a year's term.

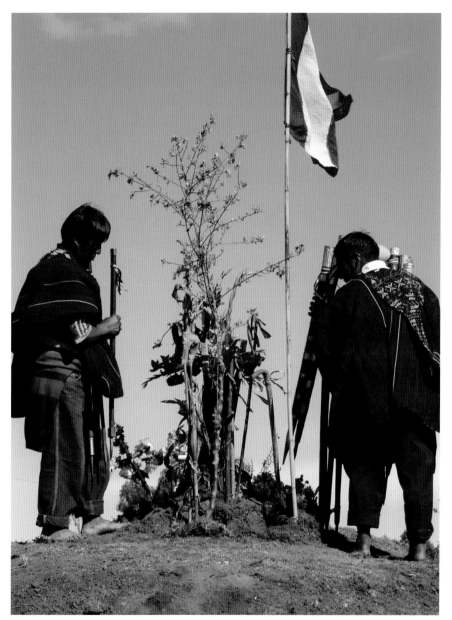

Two local authorities in Chinchero make offerings and pray during the Mojonamiento, a pilgrimage which is run around the community's boundaries.

San Cristobal wears a poncho, chumpi, and chullo created in Chinchero. The blending of native costume and ritual and those of the Catholic church is pervasive in the Andes.

the holy or sacred places." As the men reach each *mojon* (sacred pile of earth and rocks), one person gives words of worship and mentions the name of the mojon. Everybody screams *Hurray!* and starts running to the next one. The embarados hire musicians to run with people. They ask a few of the strongest men of their hamlet to dress up as women who will run first. Dancing with a white banner in hand, these runners arrive first at the mojon and dance around. They say mojon is the representation of the Mother Earth, or the female principle. Since women cannot run in the race or might have other obligations, some of the men dress up as women. The embarados run with them, carrying crosses of flowers. At each mojon they have to place and leave a cross. At the end of the day all groups of hamlets gather in the main and center mojon of the community, where the women have been waiting with a delicious feast and drinks. Dancing starts and they return home in the evening. Since it is rainy season sometimes it can be very muddy.

These traditions are a rich and elaborate mixture of traditional indigenous worship and Catholicism that has evolved since the time of the conquest. The clothing for the virgins and saints have been made traditionally from very expensive factory-made fabrics, but recently some families have begun donating handwoven textiles of intricate desgin, which carry their own special value of time and skill. The most important ceremonies occur during the time of Carnaval. Its festive character ensures the participation of young people. They begin with ceremonies for the families' domestic animals. It continues with community and inter-community celebrations.

The following festivals, *el Tupay de Anta* and *Tinkuy of Chiuchillani*, are but two examples. They have retained their authenticity and roots in bygone times.

On the day of the Mojonamiento, the embarados run up and down the mountainsides through the boundaries of their community, which are marked by *mojones* (mounds of earth and stones). Don Cirilo Pumayally says, "Our mojones are our Apus,

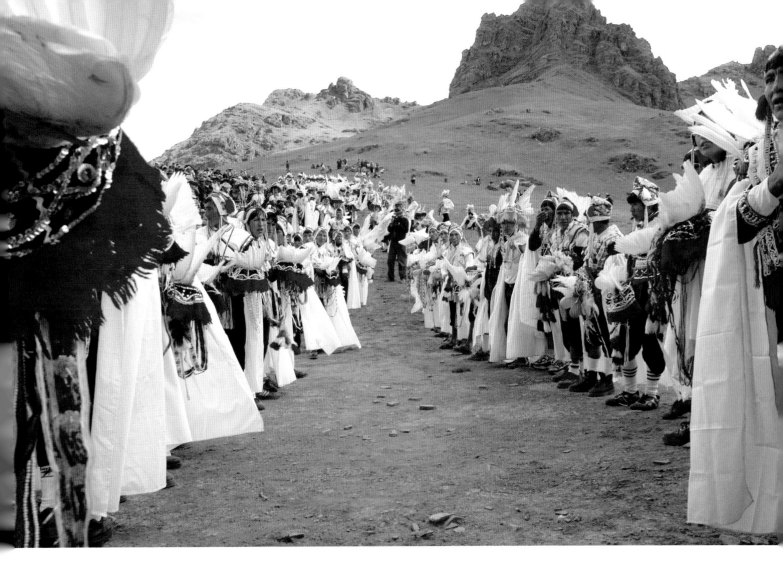

Chiuchillani Tinkuy

Tinkuy, which means "get-together," happens on the "Women's Day," the Thursday before the Sunday of Carnaval. Chiuchillani is located in the high regions of the Community of Chahuaytire of the Pisac District. It lies at 12,812 feet above sea level, to the east of the city of Cusco.

This festival is especially a meeting place for eligible men and women from the participating communities, an opportunity for them to meet their future companion. The presence of eligible women is obvious in their beautiful dress.

The communities that generally are represented are Chahuaytire, Q'anahuara, Oq'oruro, Huamachuco, and T'iracancha, each with its own group of dancers, local authorities, and their wives. The dance is perform by the men, especially bachelors called *sargentos*; their costumes and the movements of the dance represent Andean geese (*wallatas*). The authorities, dancers, and

Male dancers arrive for the festival of Chuichillani Tinkuy in Chahuaytire.

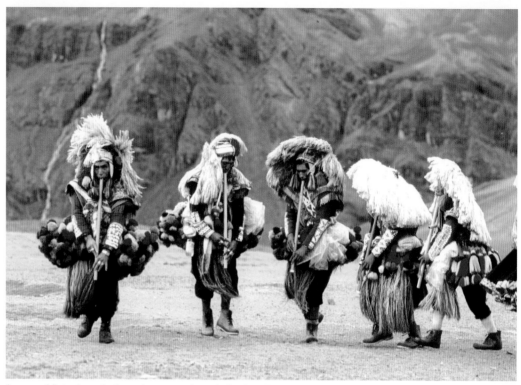

A group of flute players in dramatic costume dance during Anta Tupay in Pitumarca.

musicians come together and greet each other, and soon the dancing begins. The dancers invite — or compel — single and married women into the dance. The rhythm of the music and dance is unique and repetitive. For this festival the families weave and make new, elaborate and colorful clothes for the men as well as the women.

They say that. . . there used to exist a small bird called pataqumu, *which would gad about from one point to another lifting its little tail close by other birds, the skunk, and the deer. All these animals would meet together in this field in Chiuchillani to dance, gadding about from one place to another, their paths crossing and intertwining. Seeing the animals dancing, a fleecy cloud in the sky copied their movements, making the gestures of dancing just as those of the* animals. *This was seen by one of the people who lived close by this place.*

And so those who witnessed this event decided to come together in this place to dance. They began to invite other nearby communities to participate in this festival. In the beginning, in the times of our parents . . . there were brawls as each community tried to carry off the eligible women of the other communities. But many decades ago there came to be an agreement between communities that there would be no more brawls.

It should be pointed out that the clothing worn by the dancers represents the animals that they say originated this festival. That's why they put feathers on their heads, to represent the wallatas *(Andean geese).*

Lucio Ylla (Chahauytire)

Tupay en Anta-Pitumarca

Only a few families live in the Anta annex, community of Osefina, District of Pitumarca, at an altitude of 15,201 feet. The *Tupay*, or "get-together," happens there at the end of Friday following Sunday Carnaval. This festival, which dates back to a distant time, according to local people, allows families that live far away from each other during the year to come together. The music, the songs, and the dances provide opportunities for the young people to have amorous encounters. Friends and families get together in groups, with the men leading the dancing and playing their big flutes (*lawatus*) and the women following, dancing and singing.

The purpose of this festival is to encourage the fertility of the flocks — the alpacas, llamas, sheep — with special emphasis on the production of alpaca wool. The weavers take pains to produce the largest quantity of weavings, and especially many skirts (polleras). The women of the outlying communities who come to participate in this festival even load their skirts on horses because they weigh so much, and only begin to put them on as they get close to the place of the festival. The number of skirts a woman wears is indicative of her abilities and beauty. All, or most, of the clothes people wear to this festival are new.

My parents tell that there was a custom between different communities of kidnapping single women, but now they don't do that anymore. Instead they invite you to dance for a moment with the other group . . . but if they are single men, sometimes they convince the women to go with them.

Maria Mamani (Osefina)

The songs, sung by the women, are a little difficult to understand. They are songs inspired by their weaving, the animals, their sacred places,

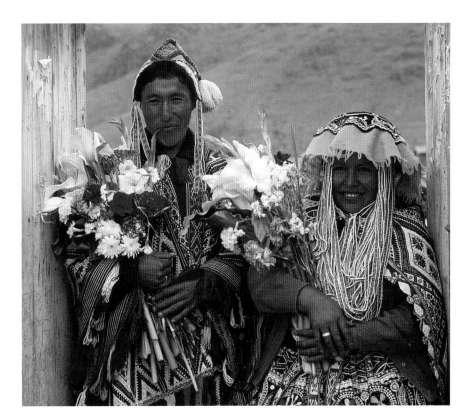

the flowers, their songs of love. They sing them many, many times.

Celestina Huaman and Cayetano Ylla at their wedding in Chahuaytire.

Marriage

In the communities out in the countryside, life together begins with a traditional Andean custom called *servinacuy* that often last for years, beginning when a couple first begins to live together. Later, if the couple wishes to, they can be married in a church and/or by civil agreement according to national law.

For this ceremony, with months of anticipation, clothes and special weavings are prepared for the bride and groom and for their families. They save materials, and plan designs, colors, and final adornments with meticulous care. In recent decades the use of synthetic fibers of brilliant colors that don't fade has become common.

SONGS

Harawis are songs of love and daily life in the Quechua culture. These are still sung today in Andean communities.

▲▲▲

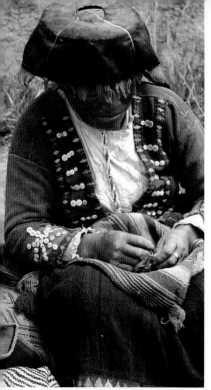

Rafaela Mamani, an elder weaver, is sorting her coca leaves in a *unkuna* (a small woven bundle).

Paris Phallcha (A Pair of Phallcha Flowers)

Altar Qaqachay paris phallchaschay	Altar rock a pair of Phallcha flower
Ritty thunichay paris t'icachay	Snow mountain pair of flowers
Nukachallachus pallayusunqui	I never took with me
Nukachallachus P'iticurayqui	I never picked you up
Q'ipay jamuccha pitiyusunqui	But a person who came after me picked you up
Q'ipay jamucma phallchachusuyqui	The person who came after me took you
Chinsi pallaycha unkuñachaman	in her chinsi (small design) bundle
Churu pallaycha llicllachallaman	in her churu shawl
Nukachalla pallayuyquiman	I would have picked you up
" P'itiyuyquiman	I would have taken you away
Tíca pallaycha llicllachallamam	in my flower design bundle
Jarpa pallachay unkuñitaman	In my nice design shawl
Antapampa Solterituschay	At the Anta pampa single man
" Manzanituschay	At the Anta pampa single apple
nukachachus suwayuraki	I never have stolen you
" apayuraqui	I never took with me
Q'ipay jamuccha suwayurasunki	The person who came after has stolen you
Llactachampi waqachinasunkipac	to make you to cry in her village
" llakichinasunkipac.	To make to suffer in her place.

▼▼▼

Piris Piris (hot pepper tree)

Piris Piris sikichapi puñurapuskani	I had sleep at the end of the piris tree
Piris Piris sikichapin puñurapuskani	I had sleep at the end of the piris tree
Soltera vidaschallaytan suwarachikuni	I got stolen my single life
Qopullawan Qopullawan soltera vidaschay	Please return me my single life
Awapakuspa puskapakuspa adquirikuskayta.	Which I acquired spinning and weaving.

STORIES

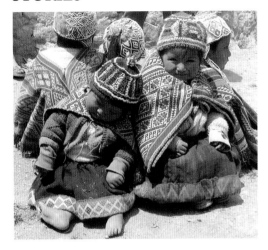

A little girl and her spinning lamb

Once upon a time there was an orphaned little girl who lived with her stepmother and her stepsisters in a village. The stepmother always gave her many more chores than her own daughters and included tasks that were almost impossible to finish. She sent her almost daily to graze the sheep and every day gave her wool to spin. In the afternoon she would take home the spun thread, and the amount she was required to spin grew every day.

One day the stepmother gave her a whole fleece and later decided to follow her to the pasture in order to see what happened, because the stepmother couldn't believe that the little girl could spin so much. She watched her from a distance. The girl arrived at a very special place and began to play with one of the lambs almost all day and only when it started to get dark did she sit down and begin to prepare the wool. The little lamb began to eat it, and the finished thread came out of her anus.

The stepmother couldn't believe it and then began to look for reasons to kill the little lamb, even though the little girl begged her not to.

The stepmother plotted to slit the throat of the of the lamb the following day, but that night in her dream the Apu told the little girl that she should escape to the hills with her little lamb before sunrise and they should disappear in the mountain.

At sunrise the stepmother told her husband that the girl had disappeared with one of the lambs. The father desperately looked for her and found her in a cave with her lamb. The little girl told him of the stepmother's plan, and the father decided to leave his wife. And so the three of them lived happily ever after.

Why weaving takes so long

There was a weaver in one town who had a lot of thread, but nobody was around to help her make a warp. So she was looking for a warping partner. Late one night, a woman with a dog arrived at her door and asked to be taken in for the night. The weaver agreed. During their conversation, the weaver told her guest about all her yarn and her need for a helper. So the guest agreed to help her.

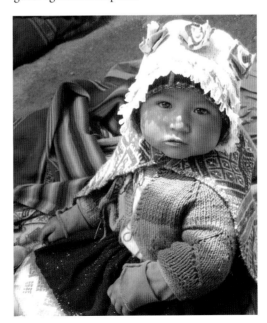

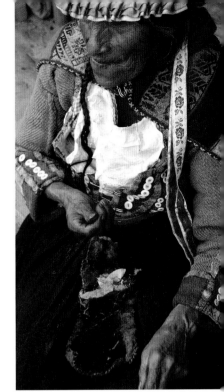

Femina Cjuno is an elder weaver of Pitumarca.

Young children of the Andean highlands learn of their cultural roots through stories and songs. These children live in Accha Alta.

Marcela Callañaupa, an elder of Chinchero, has been weaving for most of her 89 years.

Next morning, very early before the sun came up, they started warping very quickly. They finished the warp before sunrise. The weaver then realized that she had not made breakfast. So she asked her guest to make the heddles and set up the weaving. While she was preparing food, she heard the dog making noises. She went out the door to see what was happening, and she saw that the weaver was busy weaving, and was almost half-finished. But the dog was at the other end of the warp, playing with the threads and ruining the warp.

She got very angry, and said, "How can you let your dog play with my warp!" The guest was angry that her dog had been insulted. So she started unweaving the piece, untying the heddles, and then she left. When the weaver came out into the street to watch her go, the visitor instantly disappeared. The belief is that the dog was a sorcerer. And for that reason, now weaving takes days and months.

The weaver and the condor

There once was a young woman herder of alpacas who was a very a good weaver. Her family had a great many alpacas. When she went out into the mountains with the animals, she would always take her loom with her. She would spend the day weaving, so that when it was time to round up the alpacas in the afternoon, she would have to go all the way up to the top of the mountain to find them.

One day she said, "I wish someone would fly me to the top of the mountain every evening." At that moment a young man appeared and said, "I can grant you that wish. Cover your eyes with a cloth and then I can take you to the top of the mountain." So she covered her eyes, and he picked her up, and took her to a big cave at the top of the mountain where she couldn't escape. So she lived with the man.

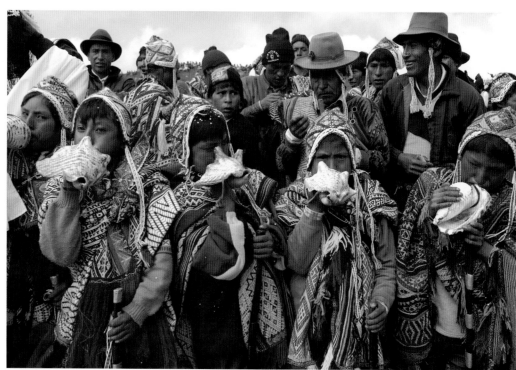

AT RIGHT: A group of boys blow conch shells during the festival of Chiuchillani. Annual celebrations of this kind engage the younger generation in their traditional culture as their world changes.

Every day her mother would take the alpacas out into the mountains, and every day she sought her daughter in great anguish. One day a hummingbird came and began chattering at her, and the mother, in her grief, struck the hummingbird and broke its leg. The bird said, "If you will tie up my leg I will get your daughter." The mother used a green thread to tie up the bird's leg, the hummingbird went to rescue her daughter, and they all went home to celebrate and make chicha.

As they were boiling the water for the chicha, the young man came to take the daughter away, and the daughter said, "I was living with this man and had a baby with him." The mother was angry, so she covered the vat of boiling water with a manta. She invited the young man to take a seat, and when he sat down he fell in. He ran screaming from the house and turned into a condor. Yes, there was no baby.

RIDDLES

Q. What is it? What gets pregnant alone, turning and turning?

A. A drop spindle.

Q. What has a hole that all men desire?

A. A poncho.

SONG

Away
Irqillaracmi awarani, warmallaracmi awarani pata pallaytan[1] awarani, ley pallaytan awarani.
Kunanka ñañay awasani, Kunanka turay awasani
palmay ramos awasani amapolastan awasani ticlla llicllapin awasani

Weaving
When I was a young girl I wove pata design and ley design. Now sister, now brother, I am weaving palmay ramos design and amapolas design in a ticlla shawl.

[1] Pata, ley, amapolas, palmay ramos pallay are techniques to create designs

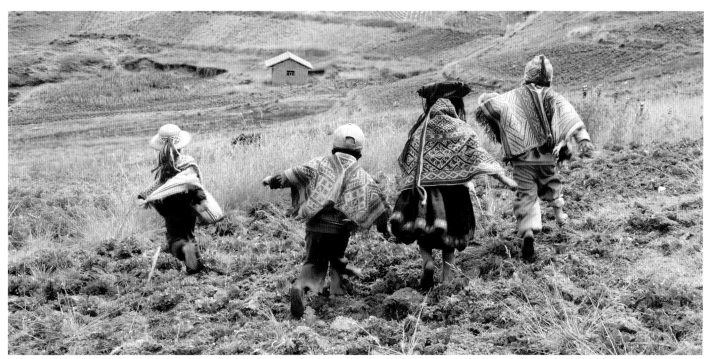

Children of Accha Alta revel in their traditional culture and dress, and the dramatic landscape in which they live.

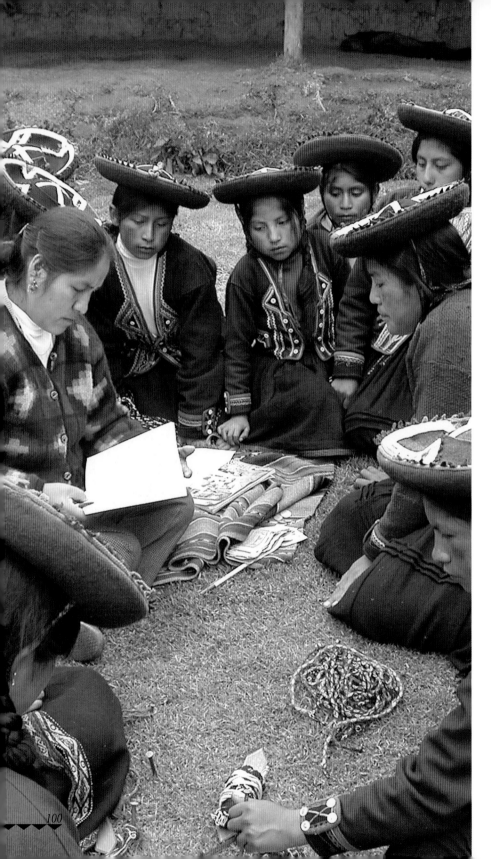

Preserving Textile Traditions

The Center for Traditional Textiles of Cusco

Many years ago, I had the opportunity to collaborate with my friends Chris and Ed Franquemont in the ethnographic work they were doing in my home village, Chinchero. With the financial assistance of Earth Watch, they created a museum focusing on the culture of the district. It didn't last, so I developed a dream of another museum in Chinchero, one that would be managed by the weavers.

I needed resources to pursue this, and found help from friends in the United States. When I met Libby and David Van Buskirk in the 1980s, I shared with them the rapid loss of tradition that I was seeing. In 1994 they contributed seed money through the non-profit organization, Cultural Survival, and that was the beginning of the Chinchero Culture Center, which existed

The author spends much of her time working with the village weaving associations. Here, she coaches a group of young girls in the Jakima Club in Chinchero. Engaging the next generation in traditional weaving is an important goal of the Center.

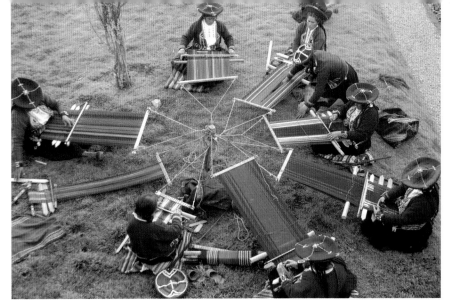

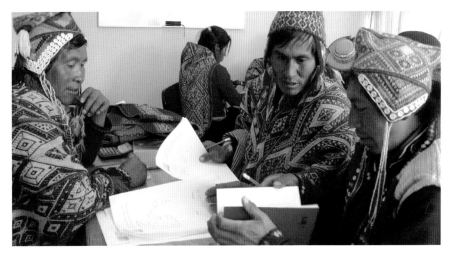

for a few years. During this time I conducted research on the surviving traditions, interviewed the elders, and worked with the children. Besides the Van Buskirks, many friends volunteered their experience, ideas, and time – Maria Tocco, the Franquemonts, Betty Doerr and Tim Wells, my extended family, and others.

I had been going out into other communities in the Cusco Department for some time to look at textiles. I went often to the Pisac market, where one can find textiles from many villages. I realized that in some areas textiles were disappearing or changing, and that these traditional techniques should be preserved. I believed that locating a museum in Chinchero would limit that effort. So I thought, "What if I dream of a bigger project? What would be the next step?" And these questions led to the idea of locating a center in Cusco, one that would represent the weaving of many parts of the Department of Cusco. We called it the Center for Traditional Textiles of Cusco.

My dream was to have a museum that would represent the rich Cusqueñan textile tradition, as well as connect today's weavers with each other and with people from the outside world. It could be a "hub" for cultural and technical interchange among weavers, and it could also promote community textiles and economic development. It could help develop leadership at the local level, and it could create opportunity for our youth.

Since 1996, the Center for Traditional Textiles of Cusco has been an established non-profit organization that aims to revive and preserve Incan textile traditions and to provide support for the weaving communities. We focus on

ABOVE LEFT: A young weaver from Chinchero teaches backstrap weaving to a student at Santa Ana girls' school in Cusco. Children's groups now exist in all nine communities, and some are producing fine, complex textiles. **ABOVE RIGHT:** Weavers in Chinchero enjoy the communal activity provided by their weaving association. **ABOVE:** Weavers from Chahuaytire learn business skills in a pricing workshop at the Center.

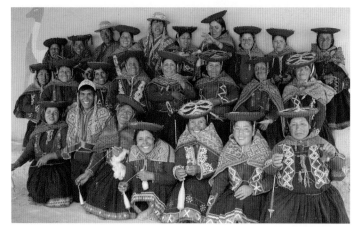

Centro de Tejedores Munay Pallay Awaqkuna de Accha Alta

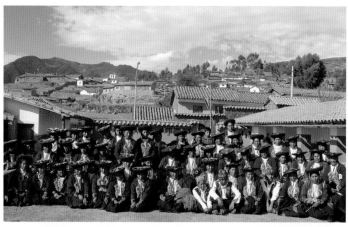

Centro de Tejedores Away Riqcharichq de Chinchero

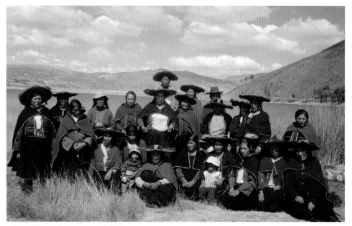

Centro de Tejedoras de Acopia

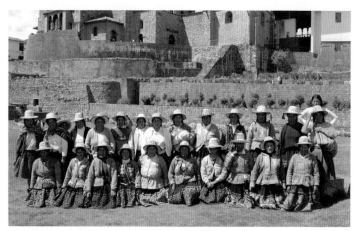

Asociación de Mujeres Artesanas Surphuy de Santo Tomas

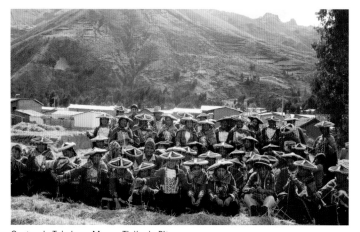

Centro de Tejedores Munay Ticlla de Pitumarca

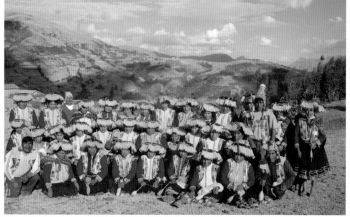

Centro de Tejedores Watay de Sallac

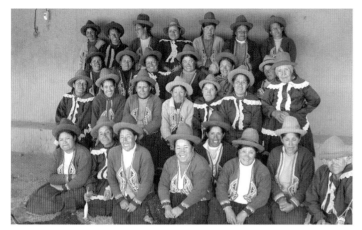
Centro de Tejedores Virgen Immaculada Concepción de Mahuaypampa

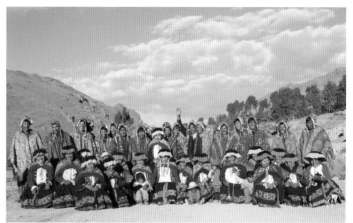
Centro de Tejedores Inka Pallay de Chahuaytire

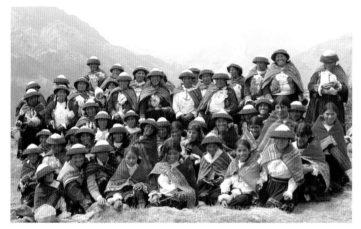
Centro de Tejedores Away Paccharichiq Pallay Tika de Patabamba

marketing good quality work and educating Cusqueñans and visitors to the area about the value of this rich cultural patrimony. We work with the young to secure the future of traditional textiles in our society.

Our work in the communities

The Center supports groups of weavers in nine communities by helping them organize and manage their activities, revive and improve their skills, build local weaving shelters, and by marketing their work through our retail gallery in Cusco. The weaving communities are spread across the Department of Cusco, and are chosen according to where the textile traditions are most endangered.

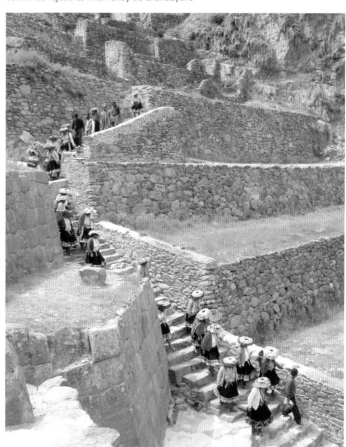
Weavers from the Sallac weaving association wend their way down an ancient Incan staircase at Ollantaytambo during an educational tour provided by the InterAmerican Foundation.

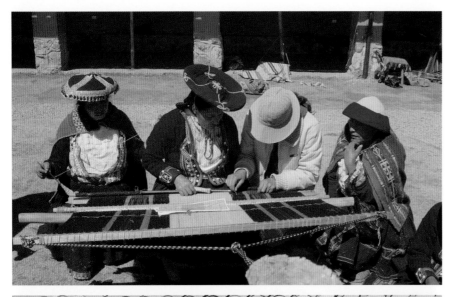

- **Chinchero** – the oldest group of weavers associated with the Center, and a model for other communities. These weavers are known for their high quality mantas, table runners, pillows, bags, and more, all woven in complementary warp technique and beautiful handspun, natural-dyed yarns.

- **Pitumarca** – noted for their work in the ancient discontinuous warp technique used to weave intricate, high-quality ticllas. These pieces are similar to the pre-Incan textiles of Paracas and Nasca.

- **Chahuaytire** – in this highland community, men weave most of the large textiles, which are noted for their supplementary warp technique and dark red colors. The women generally prepare the yarn, finish the textiles, and weaver smaller pieces such as finely woven beaded watañas for their hats.

- **Accha Alta** – since CTTC began working with weavers in this community, they have begun to abandon the use of synthetic yarns for wool and sometimes alpaca. Their predominant colors are shades of red and orange. Using supplementary warp technique, they weave very small ponchos, mantas, and fine skirt borders in complex designs. They also knit baby hats using the "popcorn" stitch and fine adult hats as well.

- **Patabamba** – weaving had almost disappeared in this remote village; only a few elderly women knew how to weave. This community has revived its fine textile tradition, reintroducing old designs of good quality.

- **Mahuaypampa** – textile production had almost ceased in the Maras area when CTTC established a weaving center there. Elders teach the younger women to weave, and after struggling for many years, they are now producing high-quality textiles from natural-dyed yarns.

- **Sallac** – Tie-dyed fabrics had disappeared

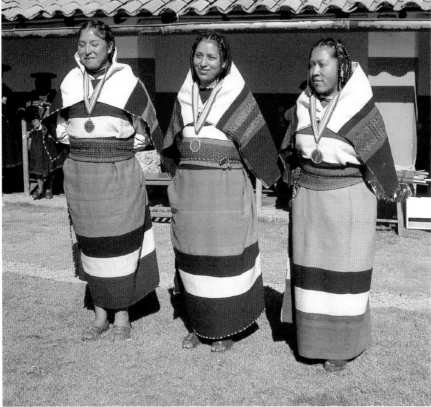

ABOVE: Weavers examine the design of the "Ice Maiden" shawl on a reproduction loom.
BELOW: Three winners in the 2007 competition model their reproduction textiles.

Entries in the "Ice Maiden" competition show great skill and attention to detail in recreating historical fabrics.

from this area because of the introduction of synthetic yarns, but through the work of the Center, tie-dyed warps using natural materials are being created with great enthusiasm. This work is distinctive and very desirable.

✥ **Santo Tomas (Chumbivilca)** – the most remote community served by CTTC lies some eight or nine hours from Cusco. It has a rich weaving tradition which is quickly being revived, including the use of such techniques as pebble weave and intermesh.

✥ **Acopia** – the newest weaving association organized by CTTC, this community had lost most of its textile traditions, but is eagerly embracing the opportunity to revive them.

The Center encourages and rewards weaving skills through a program of competitions. The newest one, in its second year, is based on reproducing the 500-year-old textiles recovered with the 500-year-old "Ice Maiden" found on Mt. Ampato in Arequipa. Studying and endeavoring to reproduce these stunning textiles has been both challenging and inspiring for today's weavers.

The Center's headquarters on Avenida del Sol in the heart of the city of Cusco includes a retail gallery where the members' work is sold and where weavers from the communities demonstrate their skills, but also a carefully-curated museum showing the origins and techniques involved in the textiles – from fiber, to dye, to weaving, to their place in Andean life.

Tax deductible donations can be made to the Center through Center for Traditional Textiles, a U.S. non-profit organization, P.O. Box 1378, New Haven, Connecticut 06505.

The Center's success in achieving its mission can best be expressed through the words of its member-weavers:

Things have changed a lot for the good since the CTTC arrived in my community to organize us weavers. Before, the majority of the women were illiterate and even our community was forgotten, but now even the authorities come to visit us knowing that we are weaving again. Now the women have their own money and we are able to educate our children, take them to the doctor when they get sick, feed them better, dress better.

Fortunata Huaman (Accha Alta)

Before the Center for Traditional Textiles of Cusco came to organize the weavers and to help us to sell our weavings, we only were living off of agriculture and our animals and our best products we always sold in order to maintain our family. But now we eat our best potatoes, eggs, milk and other products.

Catalina Champi (Patabamba)

The sale of my weavings helps me a lot with the education of my children. As a widow I am responsible for the total cost for the education of my children, although the oldest are already a little independent because they are already working. Without the profits from my weaving, it would be impossible to manage only with farming.

Pascuala Mescco (Chinchero)

When I am feeling bad I stay in my house and am bored. Then I go to weave at the local weaving center with my companions until I forget about feeling bad. When I am sad or I'm bothered and I start weaving, it quickly all goes away.

Juana Pumayalli (Chinchero)

Further Reading

Amano, Yoshitaro. *Diseños Precolombinos del Peru.* Lima: Editorial Universo, 1984.

Cahlender, Adele. *Double Woven Treasures of Old Peru.* Loveland, Colorado: Interweave Press, 1993.

Cahlender, Adele, Marjorie Cason, and Ann Houston. *Sling Braiding of the Andes.* Boulder, Colorado: Colorado fiber Center, 1980.

Callañaupa, Nilda, and Anne Pollard Rowe. "Men's Knitted Hats From Chinchero." Textile Museum Journal, Vols 38-39, 1999-2000.

Cason, Marjorie, and Adele Cahlender. *The Art of Bolivian Highland Weaving.* New York: Watson Guptill, 1978.

Cereceda, Veronica; Jhonny Dávalos, and Jaime Mejia. *Una Diferencia un Sentido — Los Diseños de los Textiles Tarabuco y Jalaq'a.* Sucre, Bolivia: Asur (Anatropologia del Sur Andino), 1993, 1998.

Corcuera, Ruth. *Herencia Textil Andina.* Buenos Aires: CIAFIC, 1995.

d'Harcourt, Raoul. *Textiles of Ancient Peru and Their Techniques.* Seattle, Washington: University of Washington Press, 1962.

Femenias, Blenda. *Andean Aesthetics: Textiles of Peru and Bolivia.* Madison, Wisconsin: University of Wisconsin Press, 1987.

Fini, Moh. *The Weavers of Ancient Peru.* London: Latin American Crafts, 1985.

Frame, Mary. *A Family Affair: Making Cloth in Taquile, Peru.* University of British Columbia Museum Note No. 26. Vancouver, BC, 1989.

_____. Lo que Guaman Poma nos muestra, pero no nos dice sobre tukapu, revista Andina 44:9-48. Cusco: Regionales Andinos Bartolomé de las Casas. Cusco, 2007.

Franquemont, Christine, and Ed Franquemont."Learning to Weave in Chinchero." Textile Museum Journal, Vol 26, pp 55-79.

Franquemont, Christine, Timothy Plowman, Edward Franquemont, Steven R. King, Christine Niezgoda, Wade Davis, and Calvin R. Sperling. *The Ethnobotany of Chinchero, an Andean Community in Southern Peru.* Chicago: The Field Museum of Natural History, 1990.

Gisbert, Teresa. *Arte Textil y Mundo Andino.* La Paz, Bolivia: Gisbert & Cia, S.A. 1978. *Guia para Teñidos con Tintes Vegetales.* Cusco: Direccion Regional de Industria y Turismo.

Heckman, Andrea. *Woven Stories: Andean Textiles and Rituals.* Albuquerque, New Mexico: University of New Mexico Press, 2003.

LeCount, Cynthia Gravelle. *Andean Folk Knitting: Traditions and Techniques from Peru and Bolivia.* Loveland, Colorado: Interweave Press, 1993.

Lewandowski, Marcia. *Andean Folk Knits: Great Designs from Peru, Chile, Argentina, Ecuador, and Bolivia.* Asheville, North Carolina: Lark Books, 2005.

Makowski, Krzysztof, A. Rosenzweig, and M. Jesus Jimenez. *Weaving for the Afterlife: Peruvian Textiles from the Maiman Collection, Vol. II.* Israel: Kal Press Ltd, 2006.

Meisch, Lynn Ann."Weaving Styles in Tarabuco, Bolivia." The Junius B. Bird Conference on Andean Textiles. *The Textile Museum Journal*, 1986, pp 243-274.

Miller, Laura M., Anne Pollard Rowe, et al. *Costume and Identity in Highland Ecuador.* Seattle, Washington: University of Washington Press with The Textile Museum, Washington, DC, 1998.

Meyerson, Julia. Tambo: *Life in an Andean Village.* Austin, Texas: University of Texas Press, 1990.

Miller, Rebecca Stone. *To Weave For the Sun: Ancient Andean Textiles in the Museum of Fine Arts, Boston.* New York: Thames and Hudson, 1994.

Murra, John V. *El Mundo Andino: poblacion, medio ambiente y economia.* Lima: IEP, 1975.

Paul, Anne. *Paracas Ritual Attire: Symbols of Authority in Ancient Peru.* Norman, Oklahoma: University of Oklahoma Press, 1990.

Popenoe, Hugh, Steven R. King, Jorge Leon, and Luis Sumar Kalinowski. *Lost Crops of the Incas.* Washington, DC: National Academy Press, 1989.

Prochaska, Rita. *Taquile: Weavers of a Magic World.* South America: ARIUS SA, 1988.

Rowe, Anne, and John Cohen. *Hidden Threads of Peru: Q'ero Textiles.* Washington, DC: Merrell in Association with the Textile Museum.

Urton, Gary. *Signos del Khipu Inka: Codigo Binario.* Cusco: Centro de Estudios Regionales Andinos Bartolomé de las Casas, with University of Texas Press, 2005.

Vidal de Milla, Delia. *El Arte Textil: Simbolismo de los Motivos Decorativos.* Cusco: Convenio Municipalidad del Cusco, 2000.

Wasserman, Tamara E. and Jonathan S. Hill. *Bolivian Indian Textiles: Traditional Designs and Costumes.* New York: Dover Publications, 1981.

Young-Sanchez, Margaret, and Fronia W. Simpson. *Andean Textile Traditions.* Boulder, Colorado: Johnson Printing, 2006.

A Selected Glossary of Textile Terms

Auli kaito (owlee kie to) – warp yarn

Awa watana – rope used to tie a backstrap loom to a fixed point

Awana – loom

Awapa – a type of finish on a fabric edge

Aymilla (eye me ya) – woman's blouse, often embroidered

Batikula – back strap

Birrete – see chullo

Buchis (boo chees) – man's short pants

Chichilla (chee chee ya) – a type of finish on a fabric edge

Chilico – man's vest or waistcoat

Chucay (choo kay) – the sewing that joins pieces of fabric together. Also chuscay.

Chullo (choo yo) – knitted cap, worn by men and boys

Chumpi (choom pee) – woven belt or strap

Chuspa (choos pa) – purse or bag, somtimes used to carry coca leaves

Chuspa con unan niyuc – coca bag with small woven-in pockets

Costale (ko stall ay) – handwoven sack for carrying produce

Fleco – embroidery or appliqué on joins or edges of fabric

Golon – woven tapestry band, usually used to decorate women's skirts

Haywarisqa (hi war iska) – a commonly practiced ritual for health, fertility, well being

Illawa (ee yaw a) – heddle rod with string heddles

Jakima (ha ke ma) – narrow belt, often woven by children

Jakira (ha kee ra) – also called intermesh, a weaving technique that creates a very thick fabric. Used for heavy belts or straps. Requires the use of string heddles to lift pattern warps.

Jilera (he lair a) – belt for the waist, used to hold up skirts

Jobona (ho bon a) – a type of woman's jacket

Julicha (hoo lee cha) – warp beam of a horizontal loom

Juyuna (hoo yoo na) – a type of woman's jacket

Kakina kaspi – warp beam

Kaulla (cow ya) – shed sword

Kenko – zigzag stitch used to join pieces of fabric together

Ley pallay (lay pa yay) – supplementary warp technique

Lliclla (yeek ya) – woman's manta or shawl

Lloque (yo kay) – yarn spun counter clockwise (Z twist)

Miñi (min yee) – weft yarn

Miñi qhuma (min yee koo ma) – bobbin of weft yarn

Miskhuy (misk ooee) – technique for twisting fiber into rope

Missa q'epi (missa kay pee) – ceremonial bundle

Montera – traditional woman's hat, usually flat brimmed

Ñawi awapi (nya we a w ape) – "eye" braid often used to finish a fabric edge

Ollantina (o yon tee na) – single-color woven band

Pallana (pa ya na) – pick-up stick

Pata pallay (pata pa yay) – sometimes called pebble weave. Often used to weave figurative bands.

Phusca (foos ka) – drop spindle

Pollera (po yerr a) – full, gathered woman's skirt

Q'epi (kay pee) – bundle, often objects wrapped in a llicla or manta

Ruki (roo kee) – beater, often of llama bone

Senqapa (sen kapa) – a type of finish on a fabric edge

Sunqupa (soon koo pa) – shed string (weaving)

Tablacasaca – man's overgarment or tunic, rarely worn today

Tacarpus – stakes to which a horizontal loom is tied

Ticlla (teek ya) – discontinuous warp technique. Also called kuchu

Tiqlla unkuña (teek ya oon koon ya) – special weaving with discontinuous warp or weft comprised of four squares of different colors. Used to lay out offerings

Tukuru (too koo roo) – shed stick

Unku (oon koo) – long shirt

Unkuña (oon koon ya) – small square textile used as a carrying cloth

Urdimbre complementaria – complementary warp technique

Verete – see chullo

Wachala – small square textile used as a carrying cloth

Wasa watana – a narrow woven ribbon with other ribbons woven across and through it

Watana – narrow woven band or ribbon

Watay – tie-dye or ikat

Wichuna – beater for packing weft yarn into a warp

Photography Credits

My thanks to those who contributed photographic images which bring the content of this book so vividly to life. They are as follows:

Sr. Martin Chambi, noted Peruvian photographer (1891 – 1973). With permission of Archivo Fotografico Martin Chambi: 14, 15

John Bacolo: 94

Milagros Conislla: 104, 105

Jeffrey Foxx: 46, 81 (top right)

Linda Gordon: 58 (lower left), 61 (bottom), 74

Linda Ligon: cover

Sandra Teixeira: 85 (center left)

Paula Trevisan: 19, 21, 24 (right), 26, 27, 28, 29, 30, 31, 32, 33, 34 (right), 37 (left), 38, 39, 40, 41, 42, 43, 44, 45, 48, 49, 54, 58, 59 (upper left and right), 61 (upper left and right), 62, 63, 64, 65 (upper right), 68, 69, 70, 71, 72, 76 (left and upper and middle right), 77, 78 (all but upper left), 80, 81 (all but upper right), 82, 83, 84, 85 (all but center left), 86, 87, 89 (bottom), 96, 97 (upper right), 99, 101 (upper left), 103 (upper right).

Linda Troyak, 92

A. Tim Wells: 24 (left), 34 (right), 47, 62 (bottom), 64, 89 (top), 91, 101 (upper right)

David Van Buskirk: 65 (left), 75, 98 (upper left)

Eliza Wethey: 20

All remaining photographs were taken by the staff of the Center de Traditionales del Cusco.

Index

Bold-faced numbers indicate photographs